Belongs To

Dedication

This book is for you, dear Colorist.

"May your time spent coloring these pages bring you joy, plus lots of fun mixed in with plenty of relaxation.."

Copyright © Kreative Kolor - All Rights Reserved

No part of this publication may be reproduced, stored in a retrieval system, or transmitted in any form or by any means, electronic, mechanical, photocopying, recording or otherwise, without the prior written permission of the publisher.

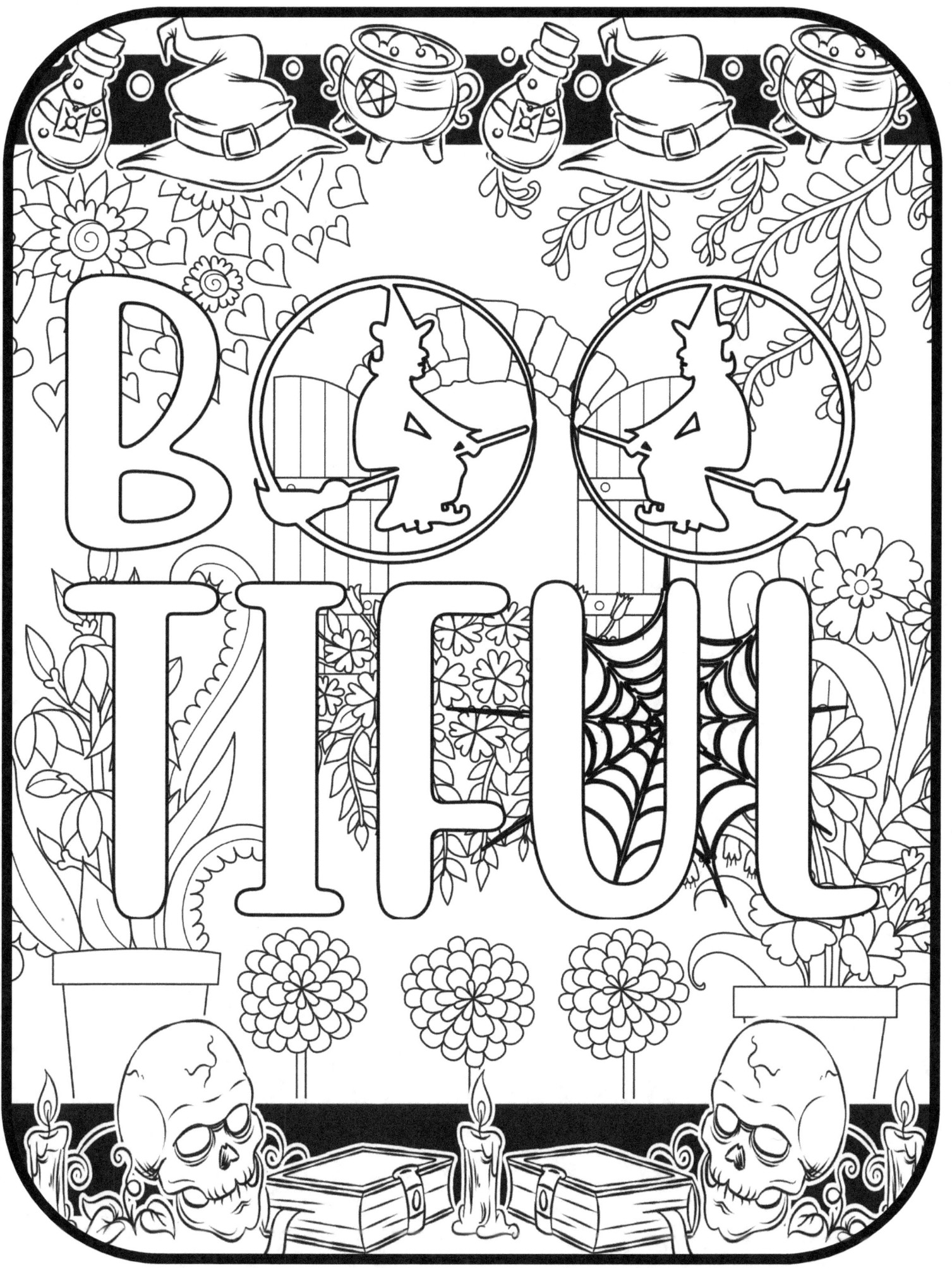

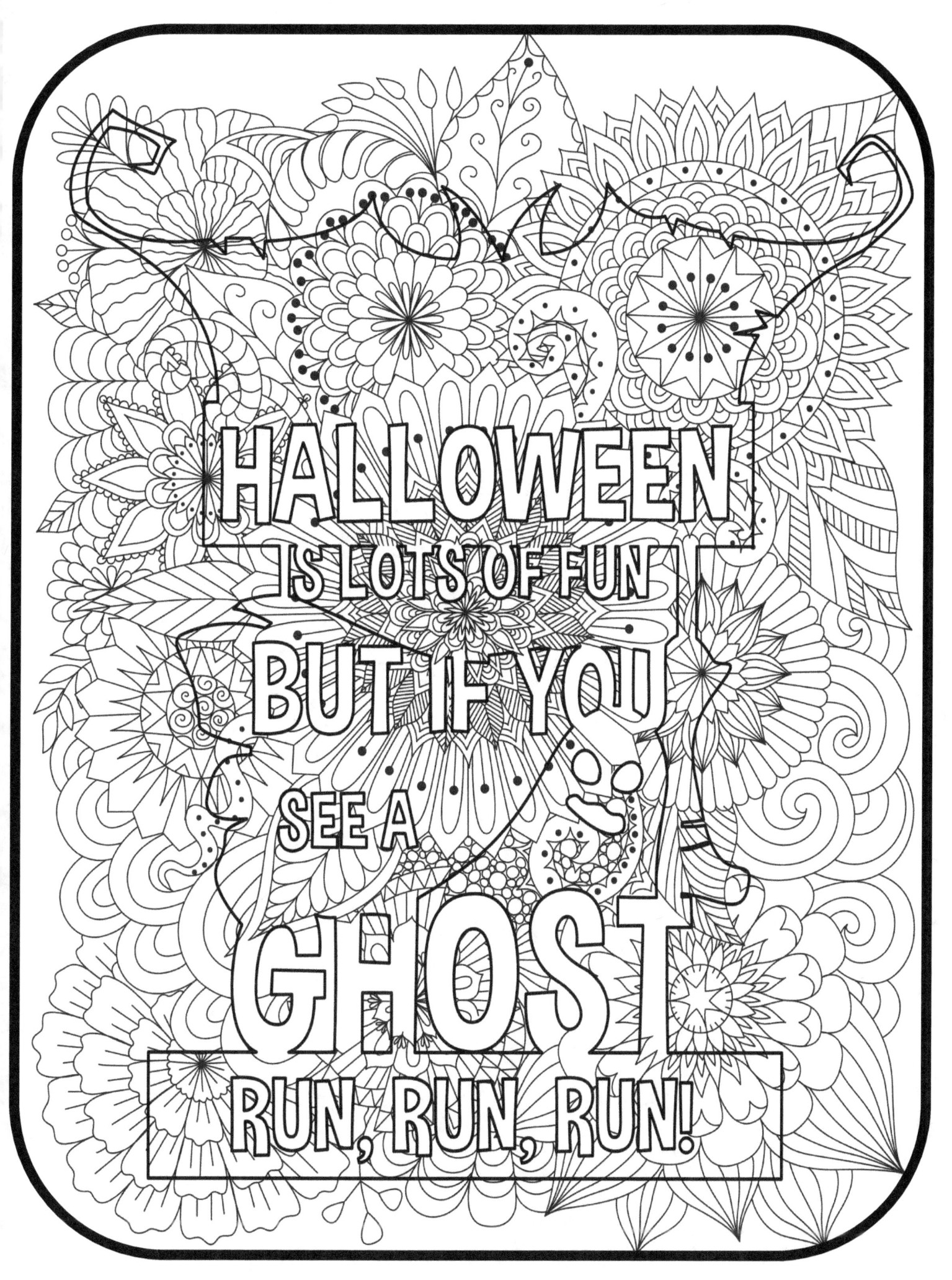

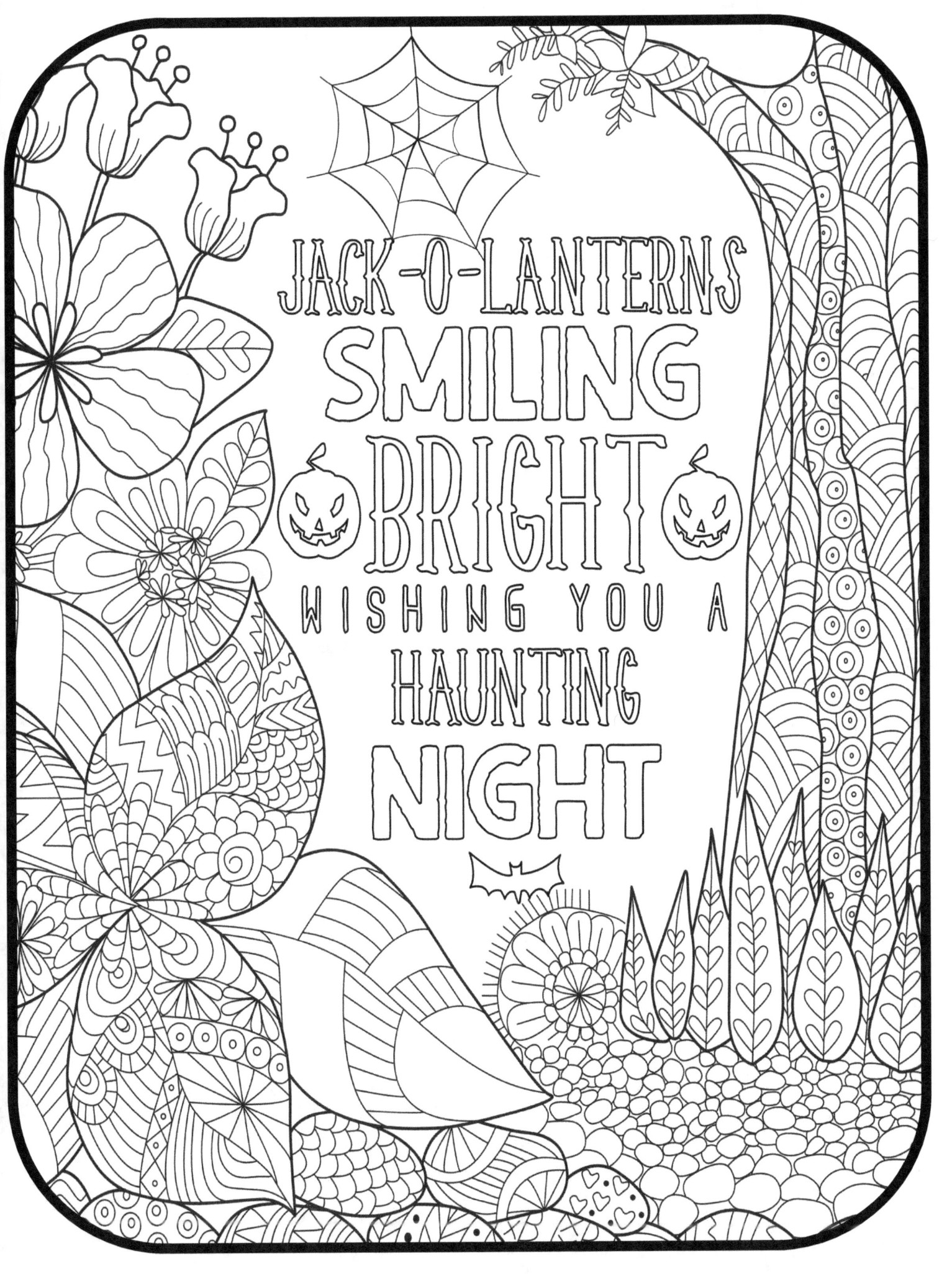

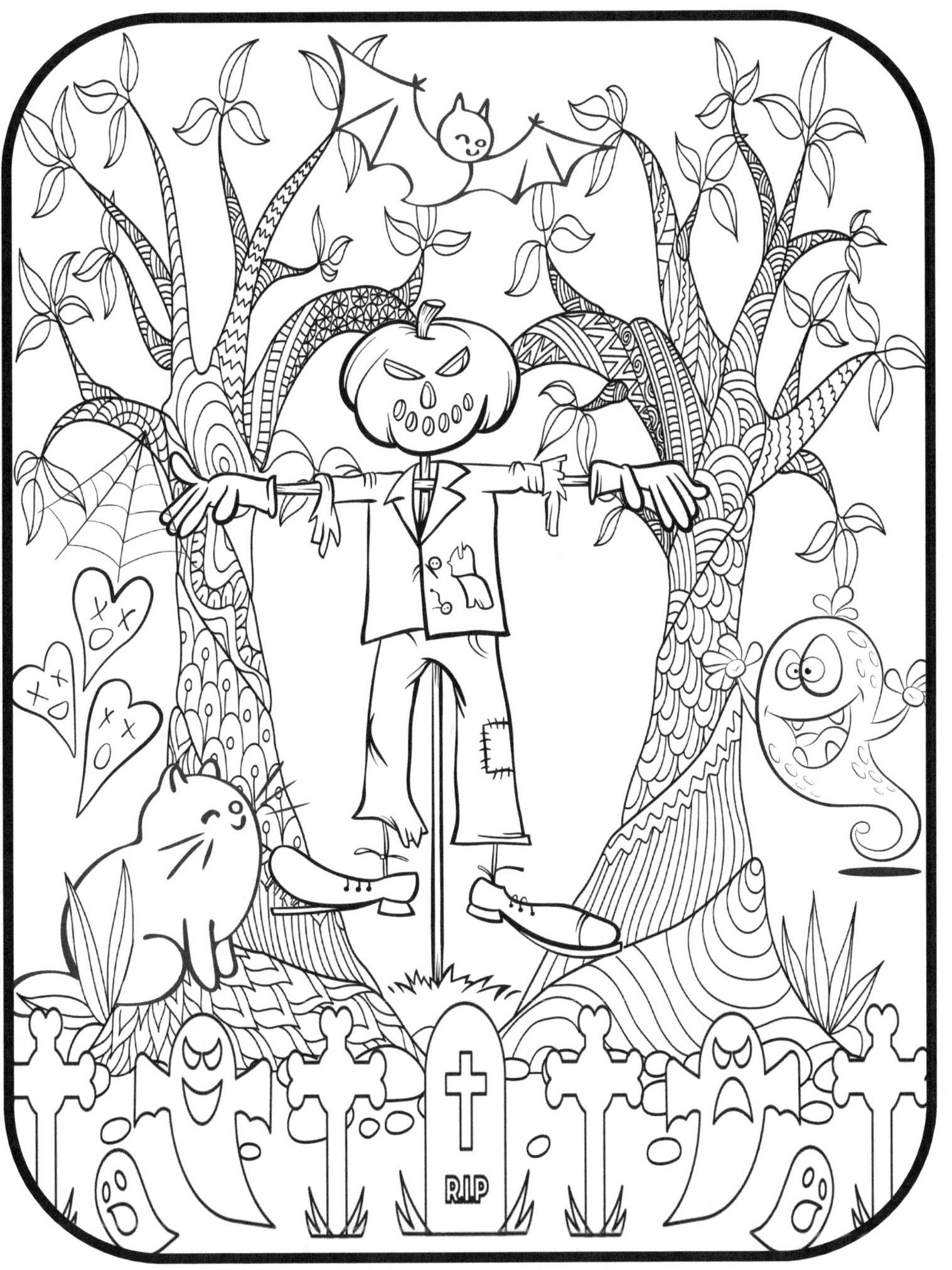

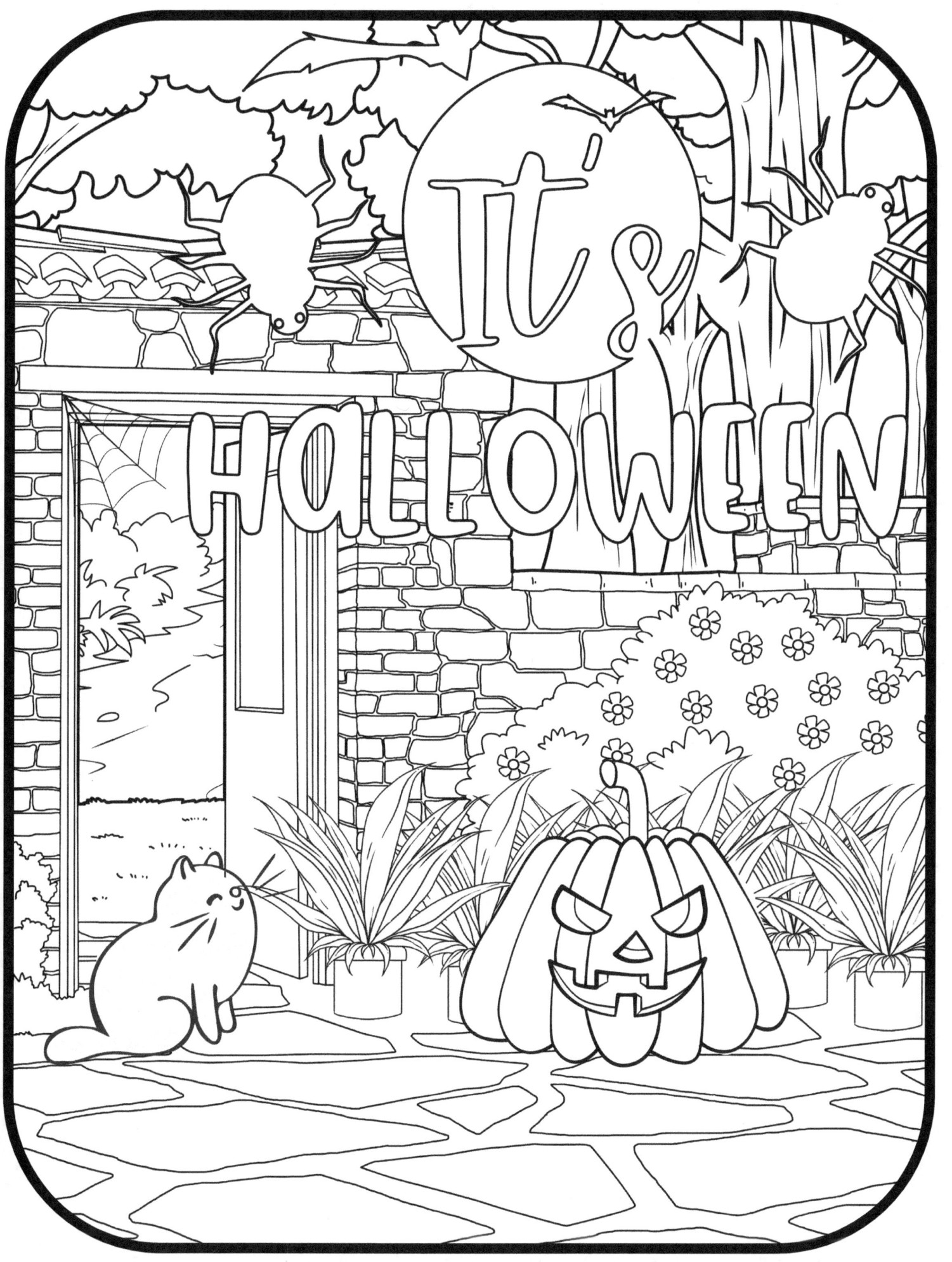

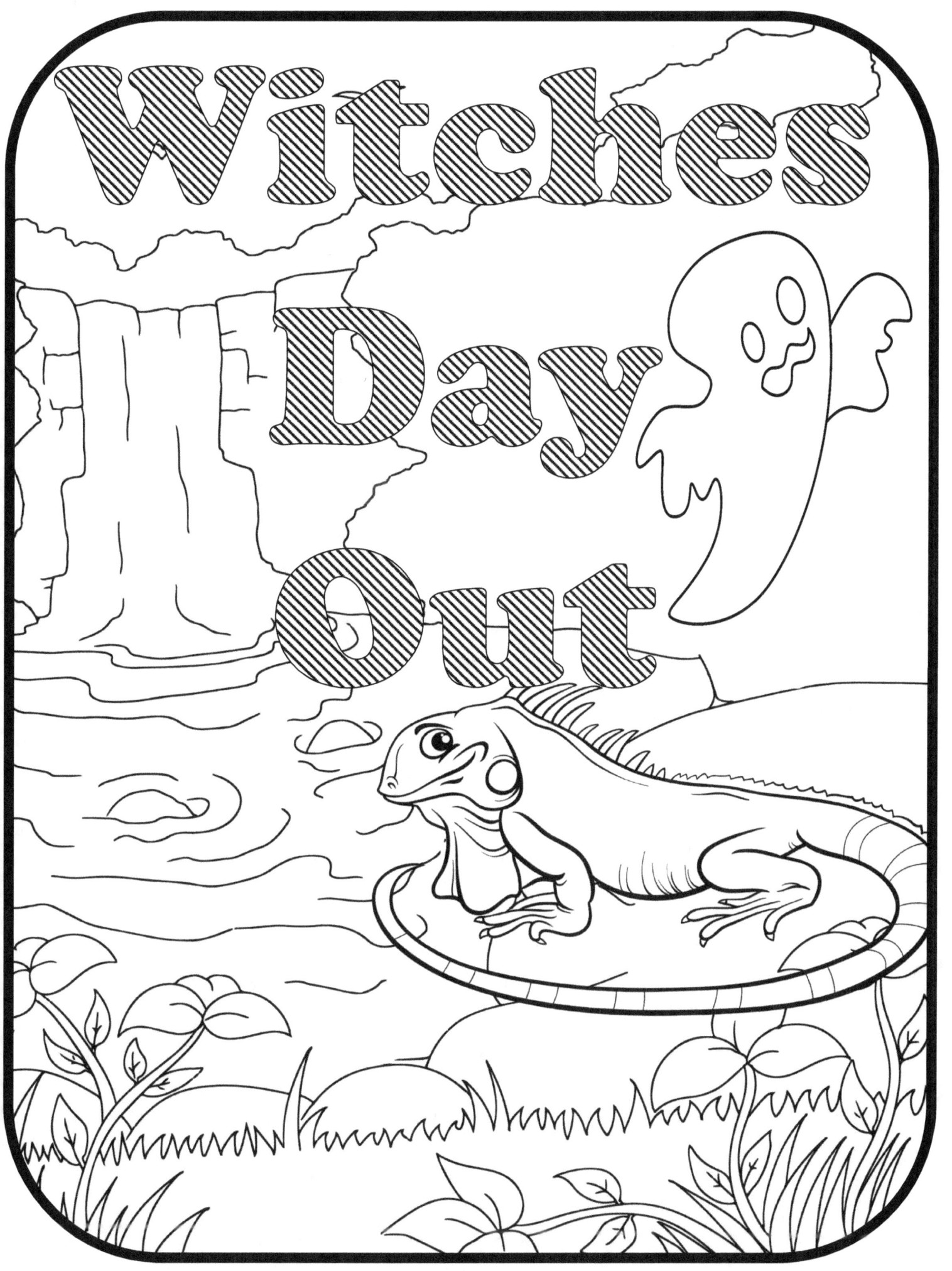

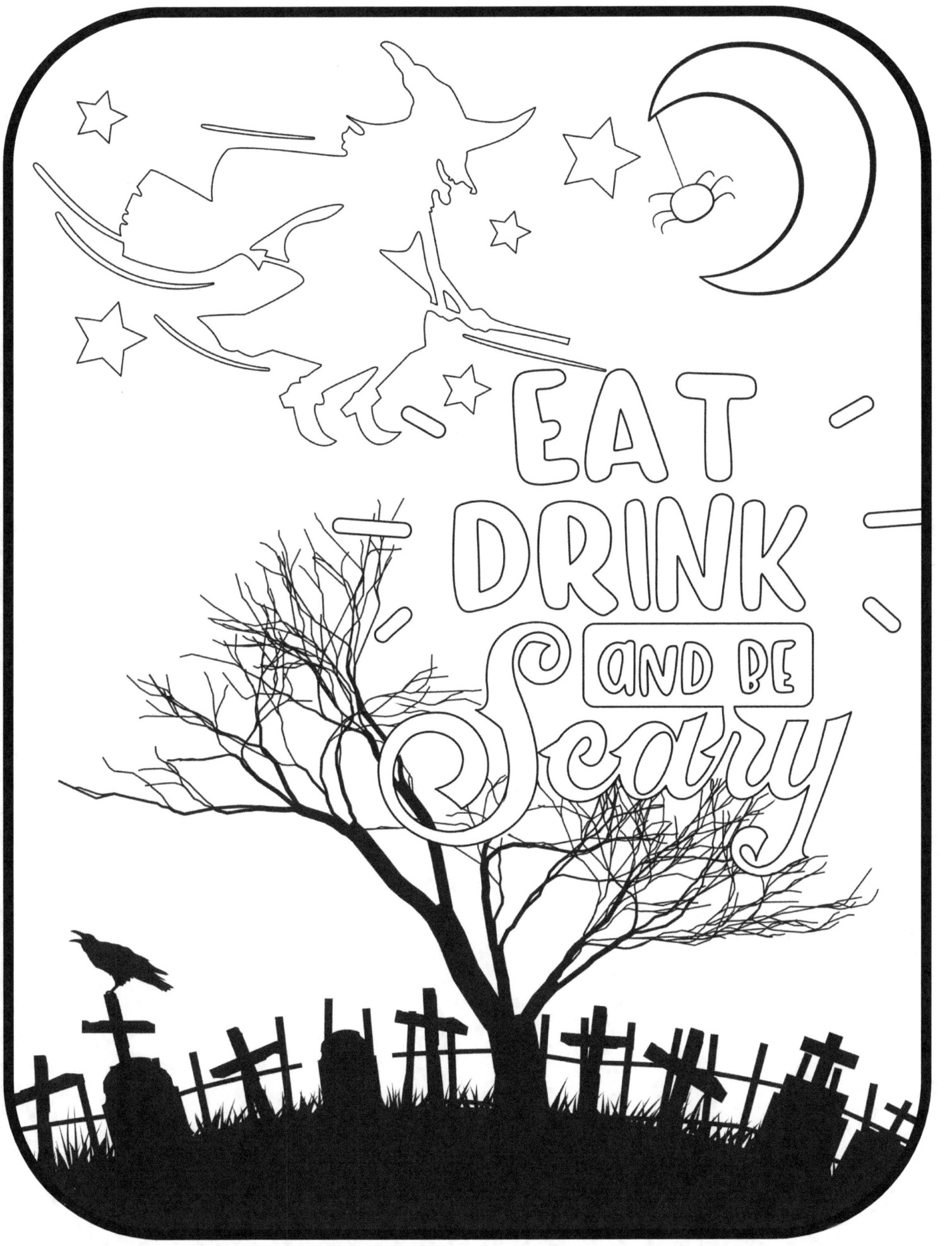

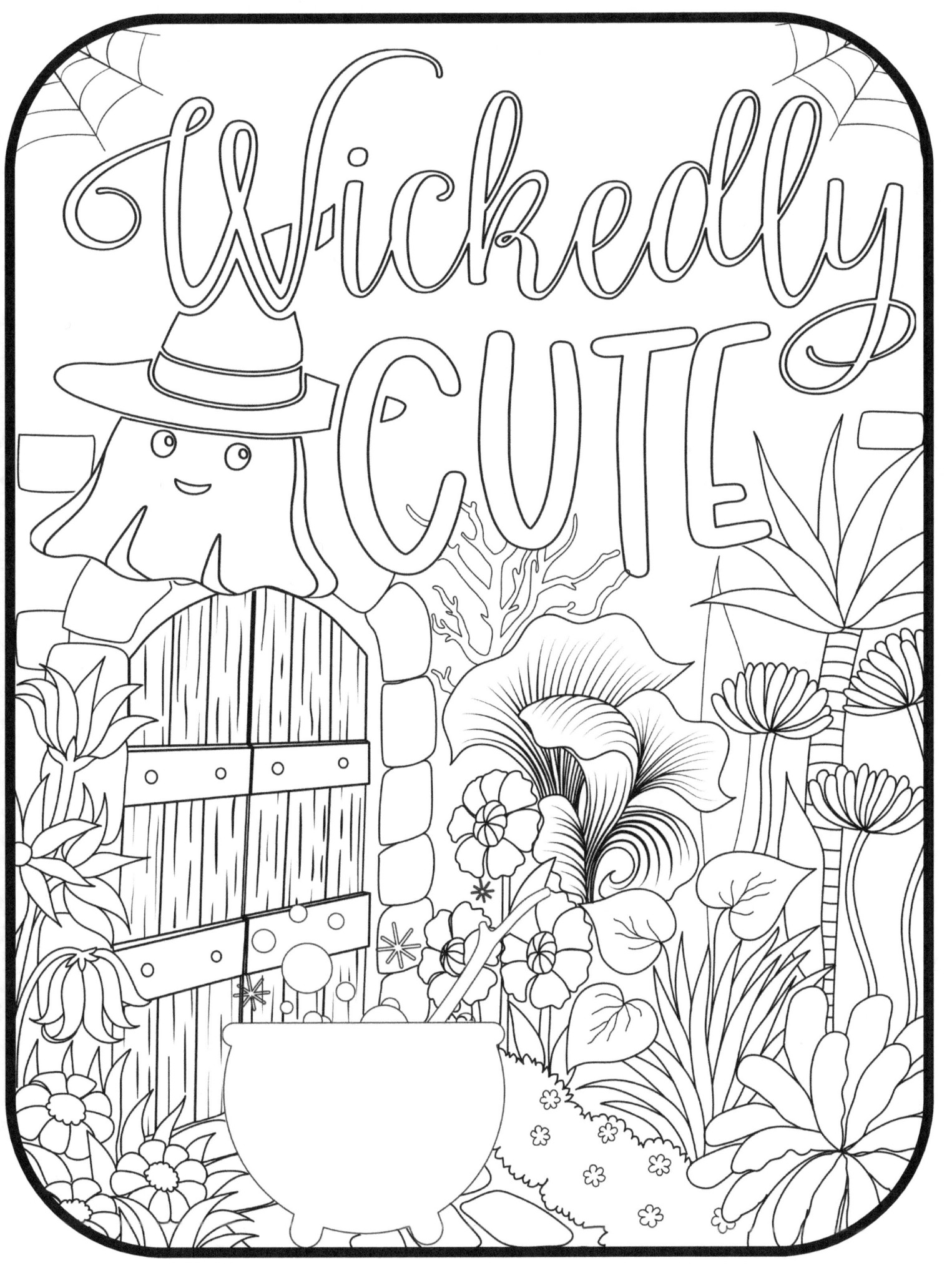

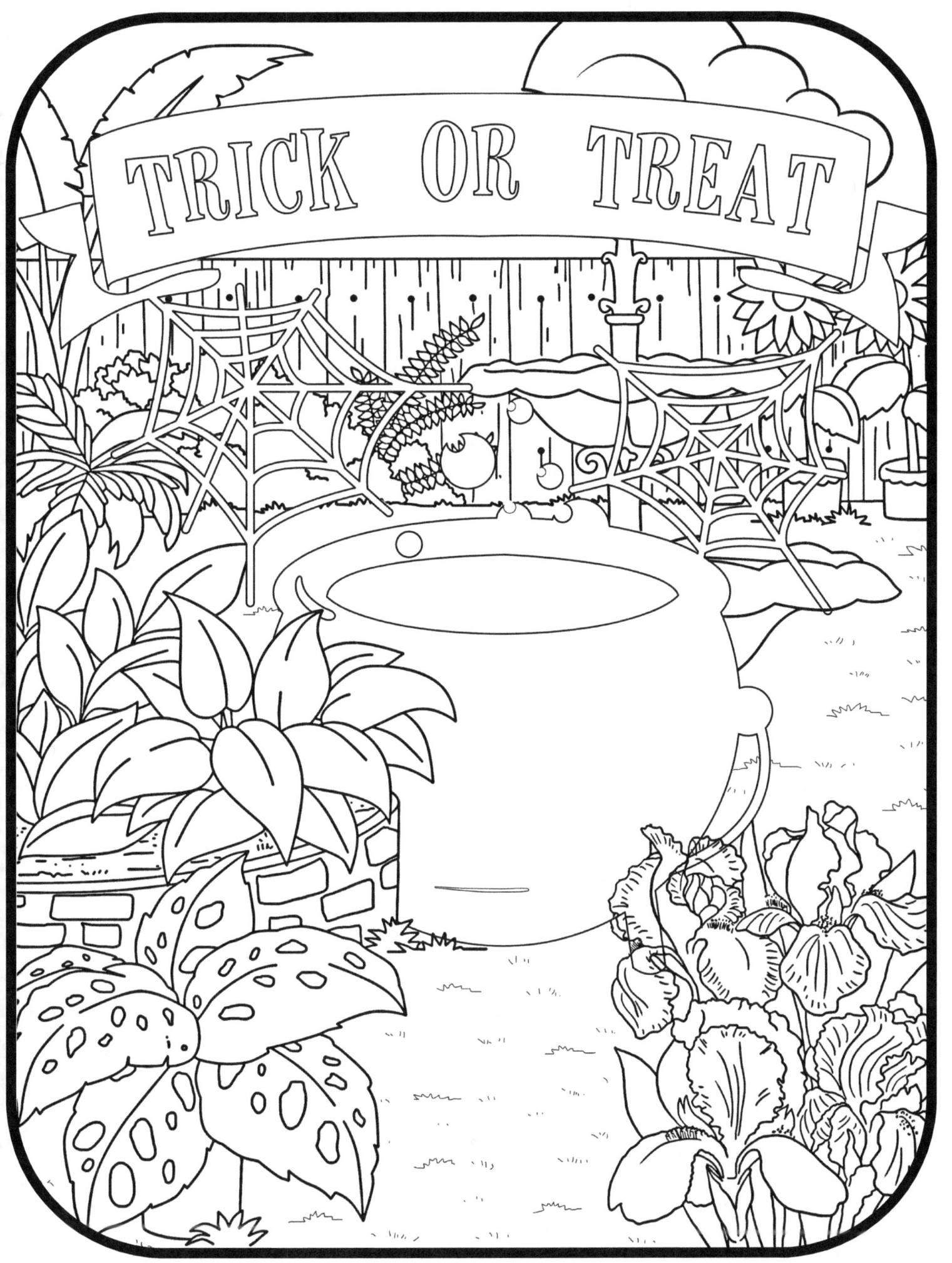

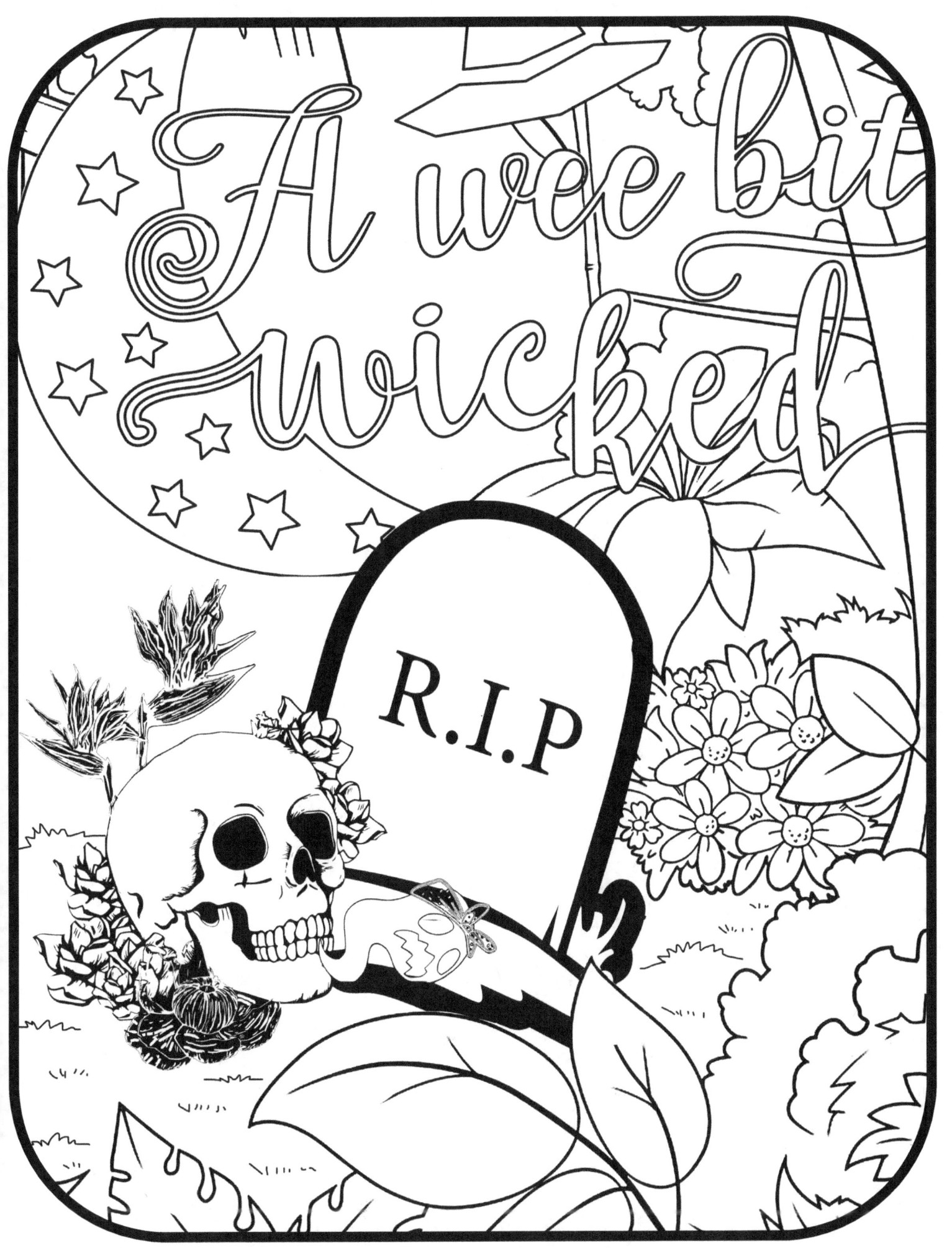

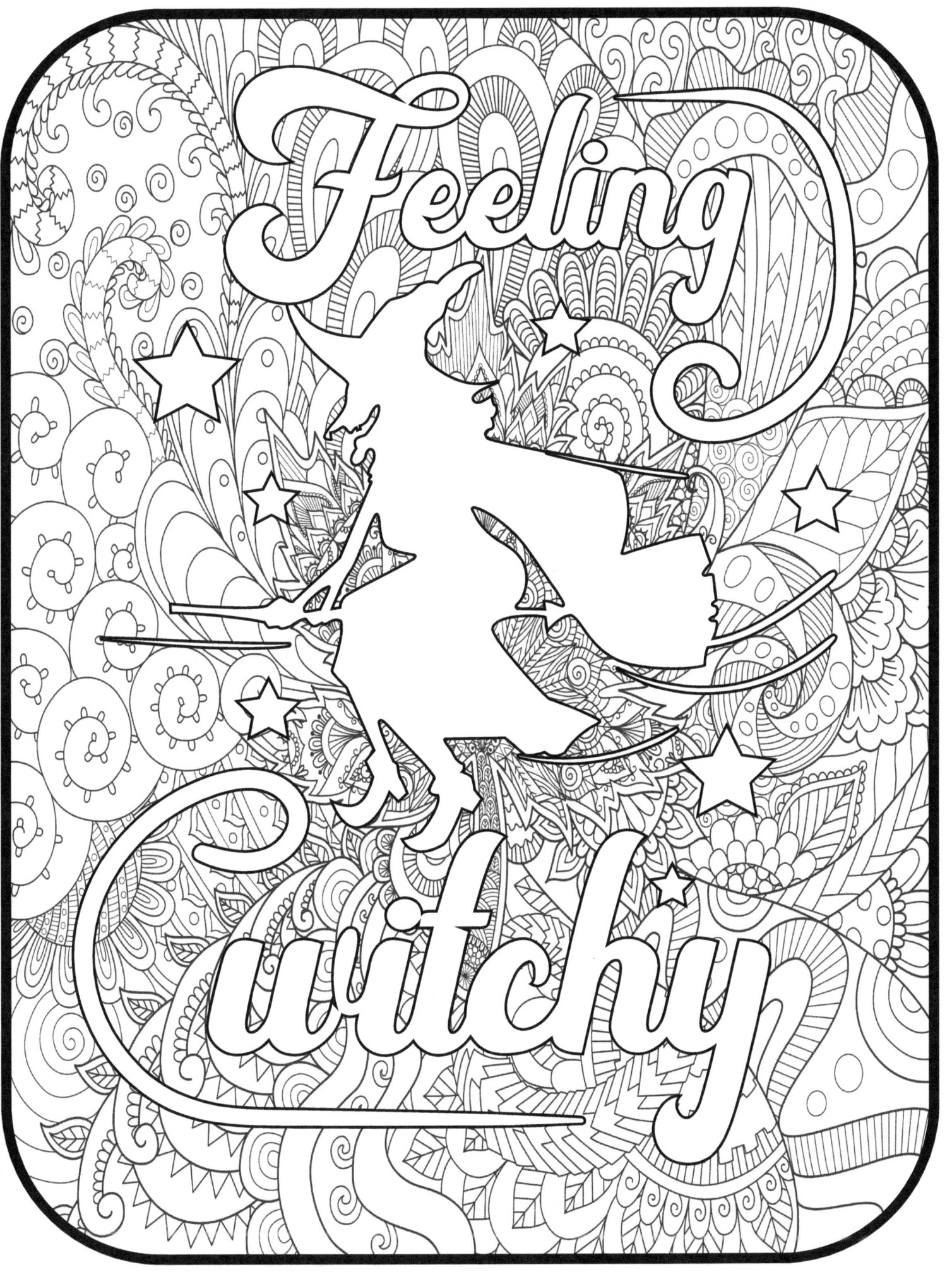

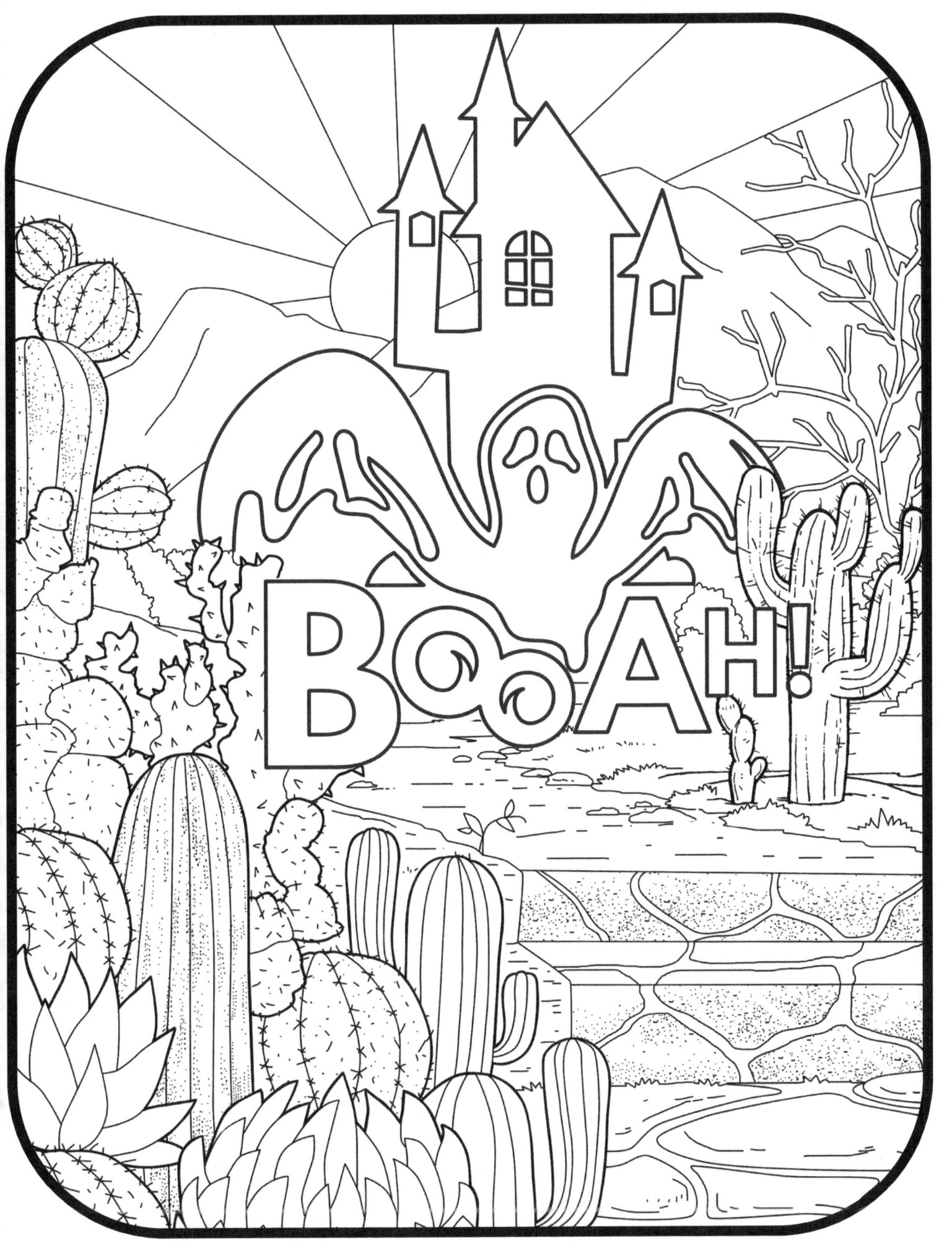

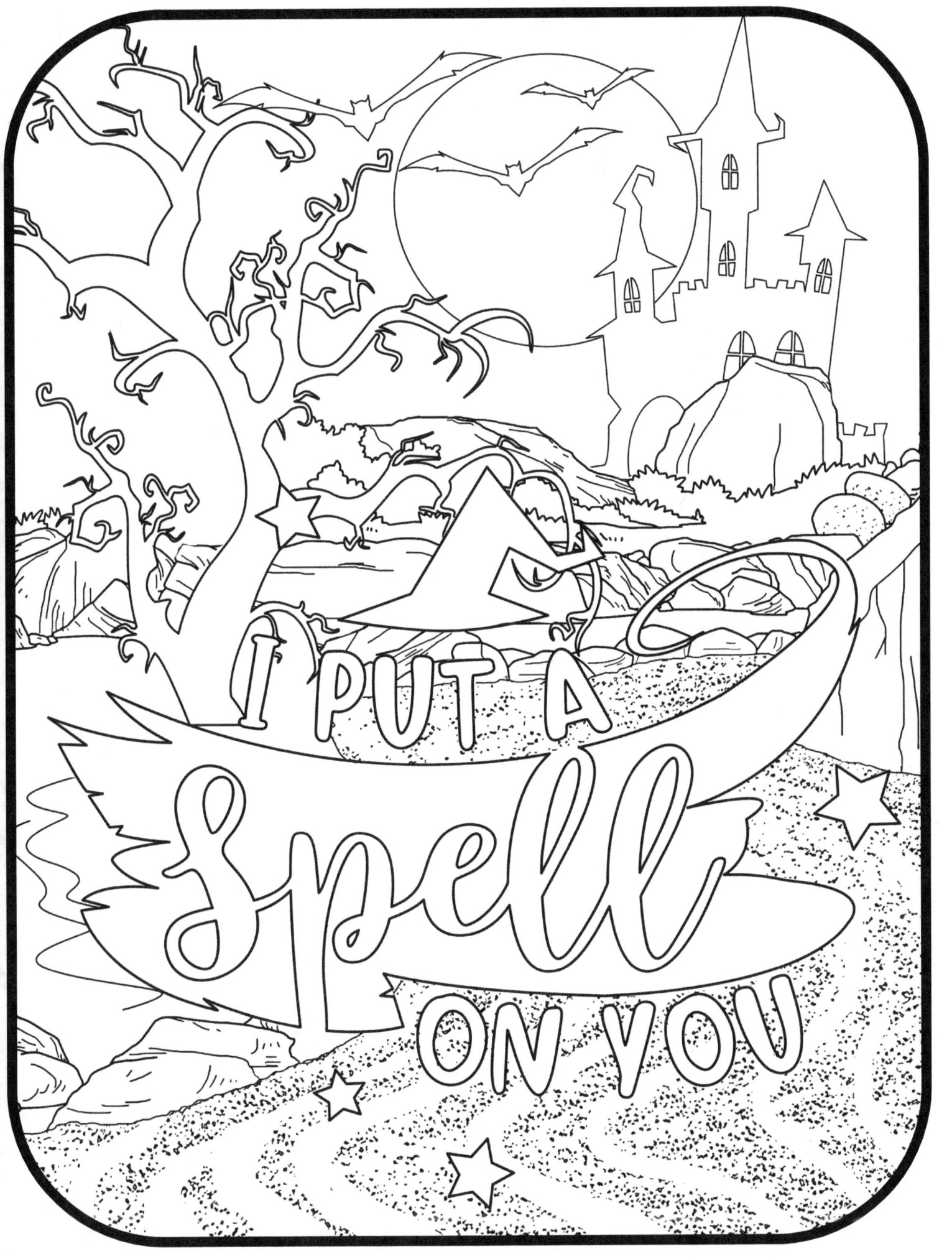

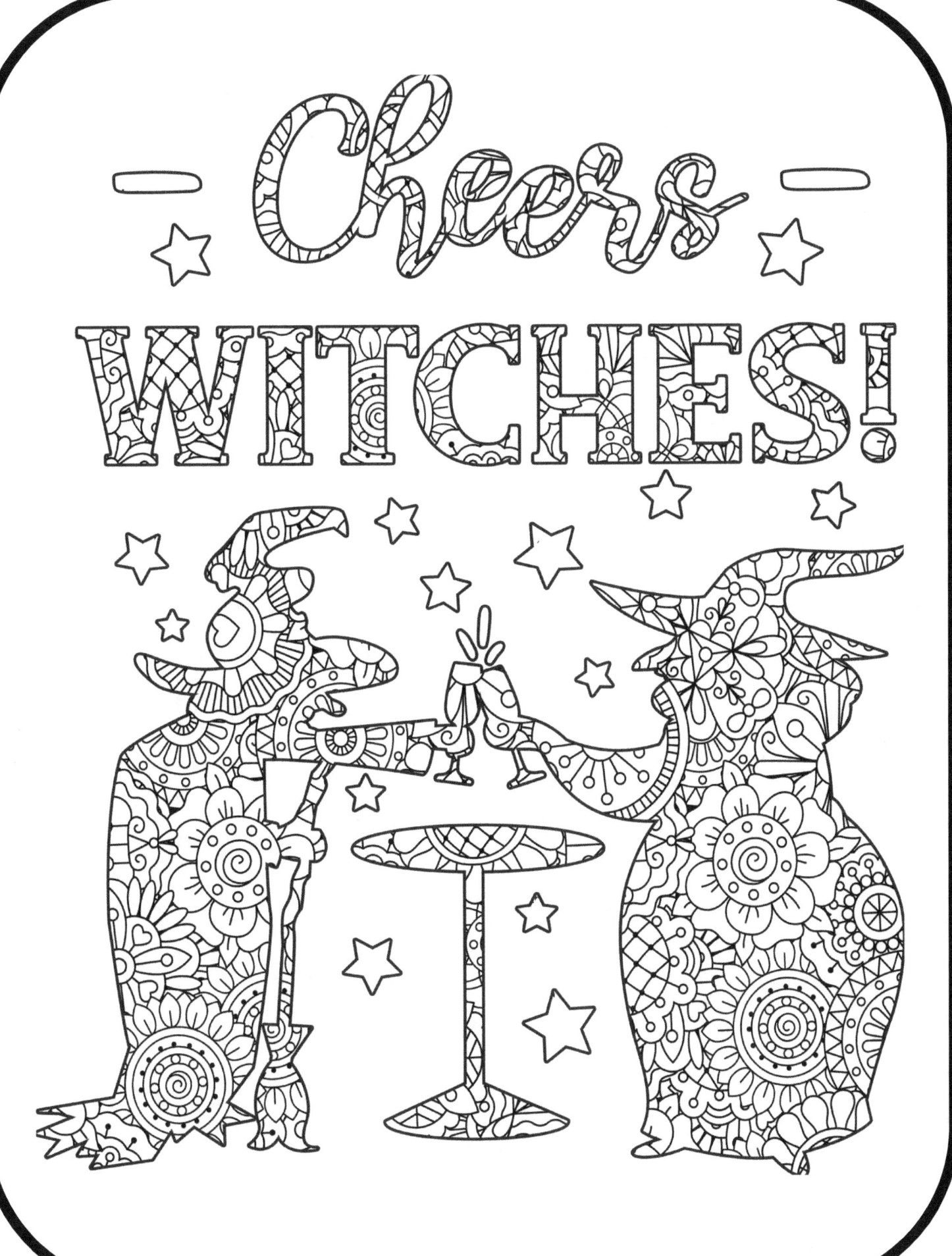

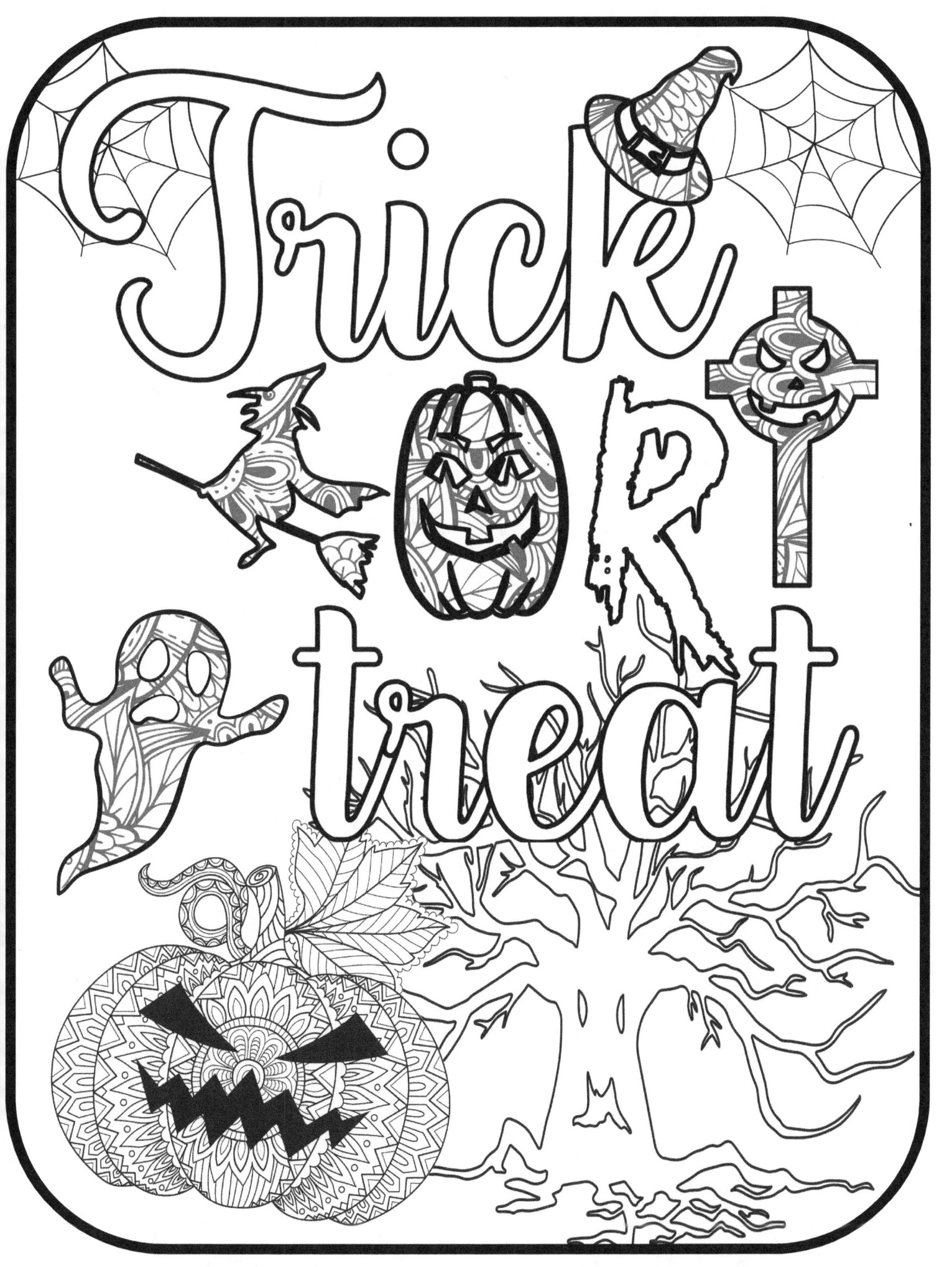

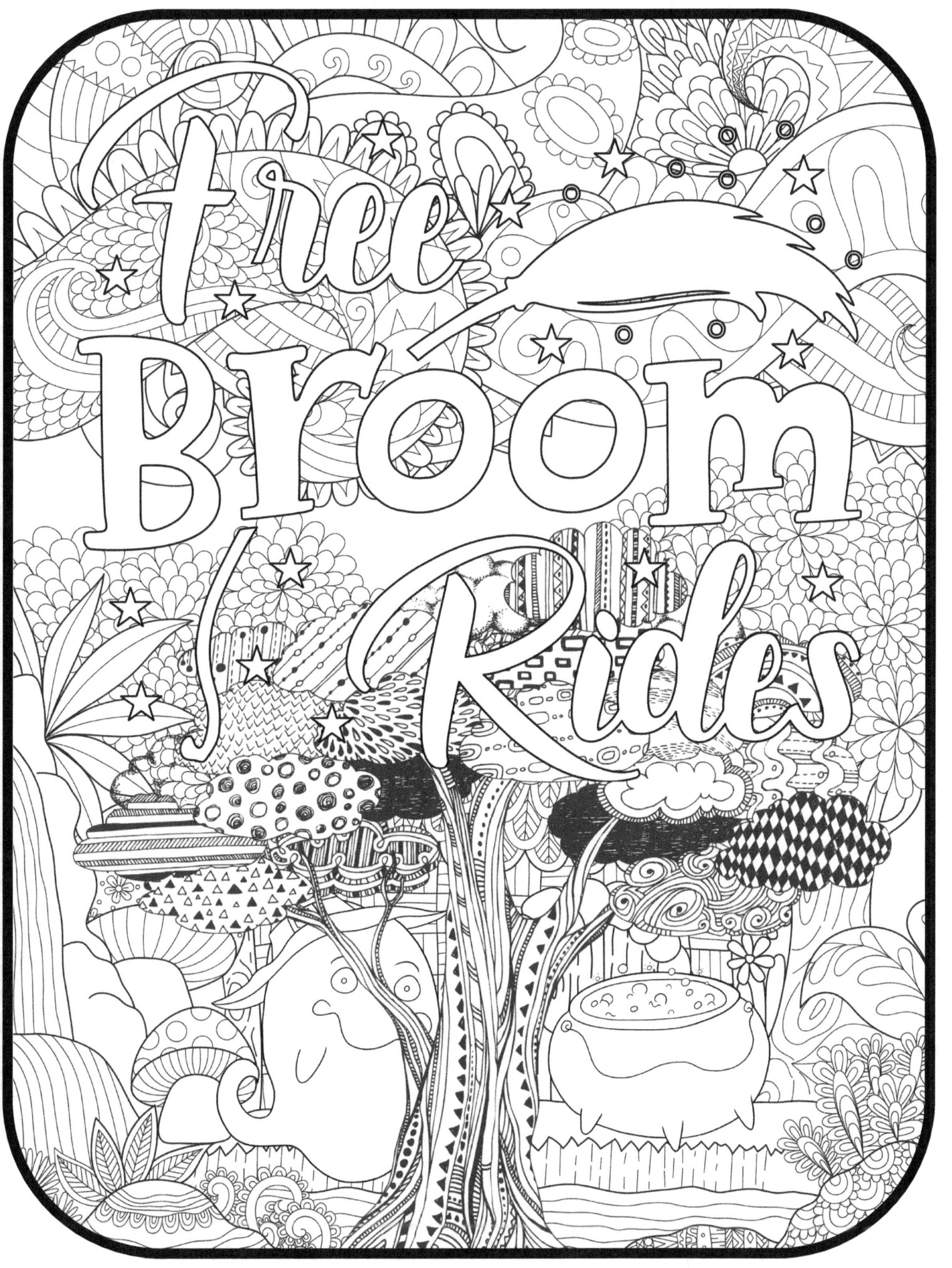

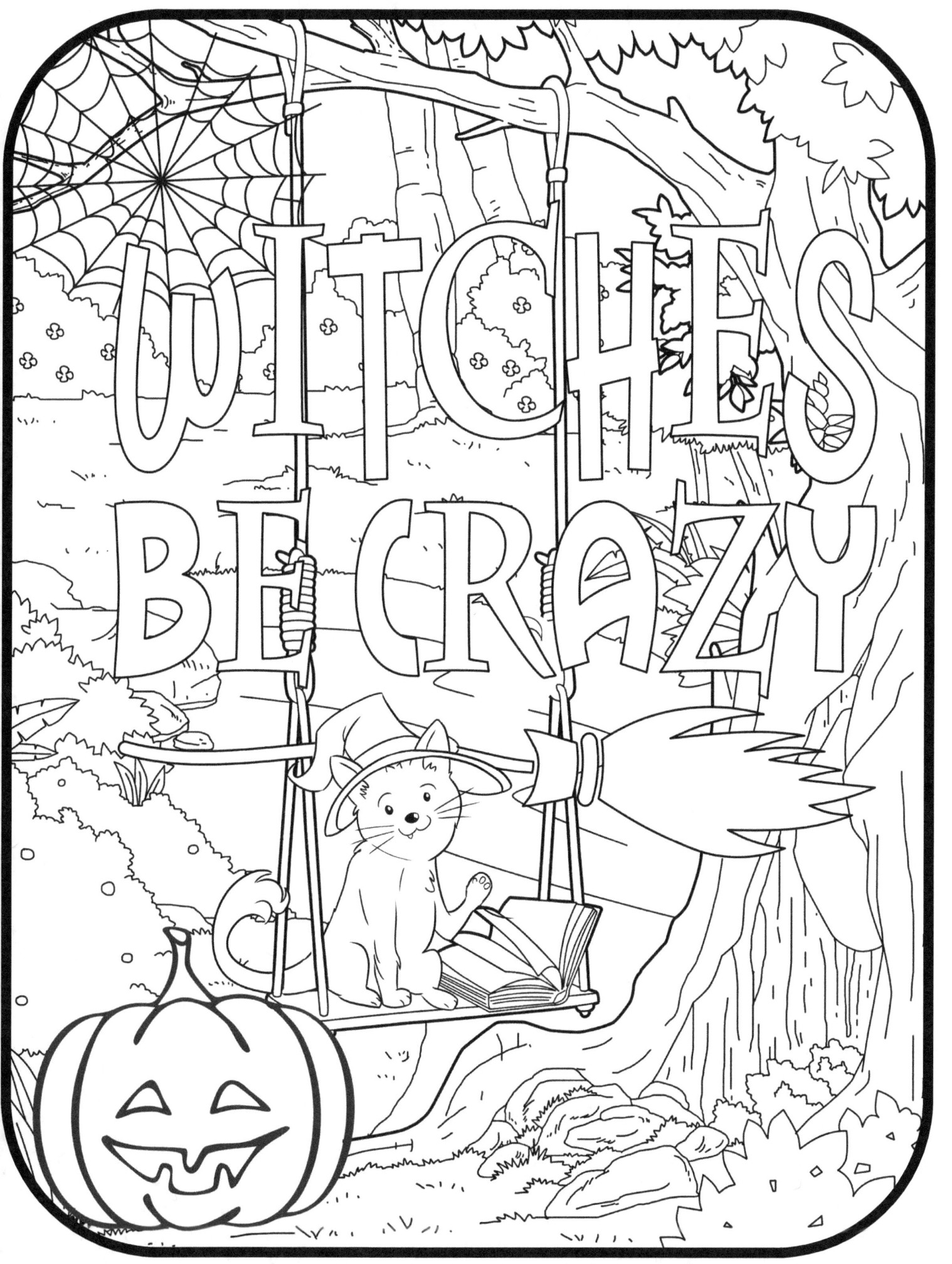

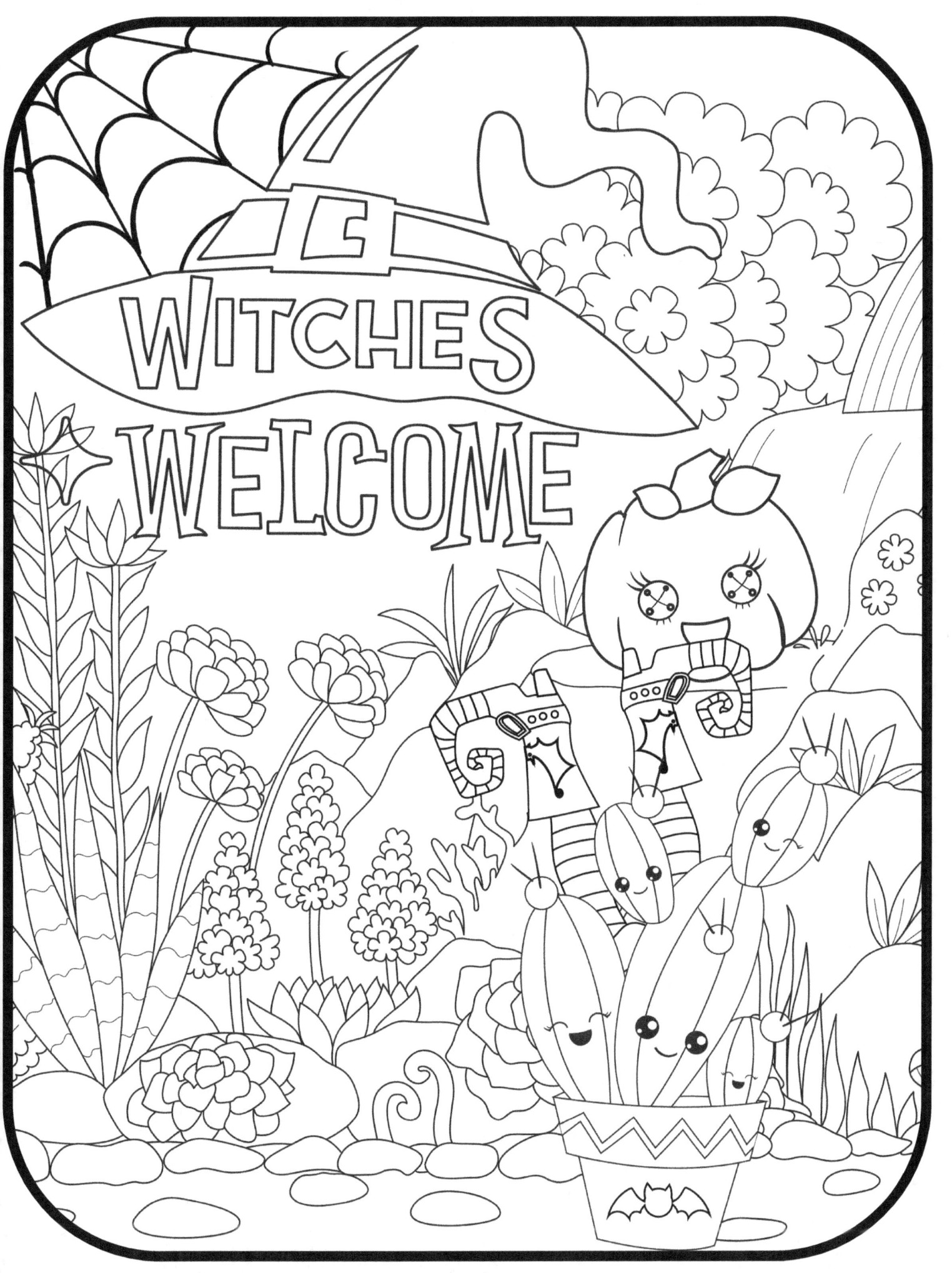

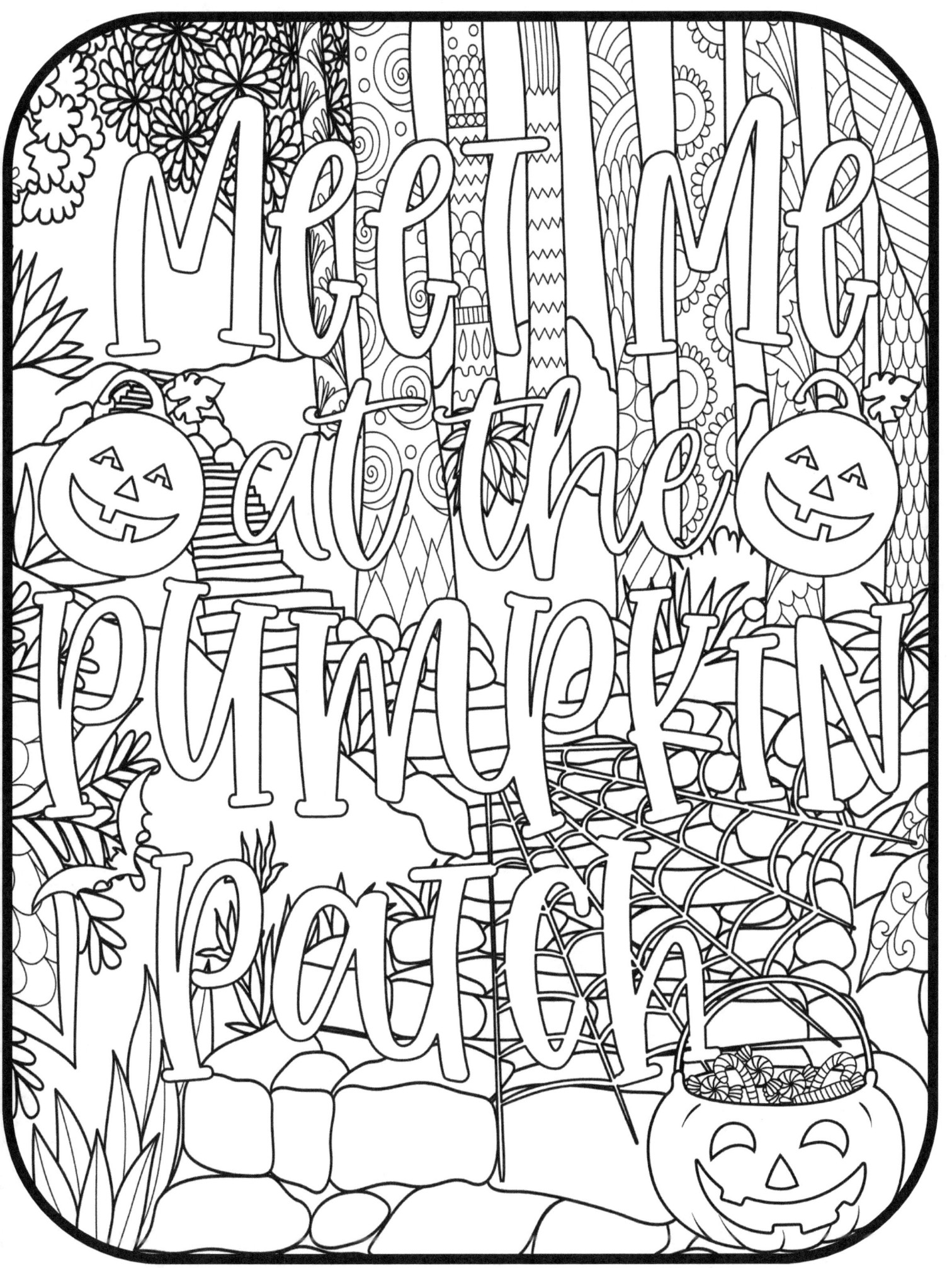

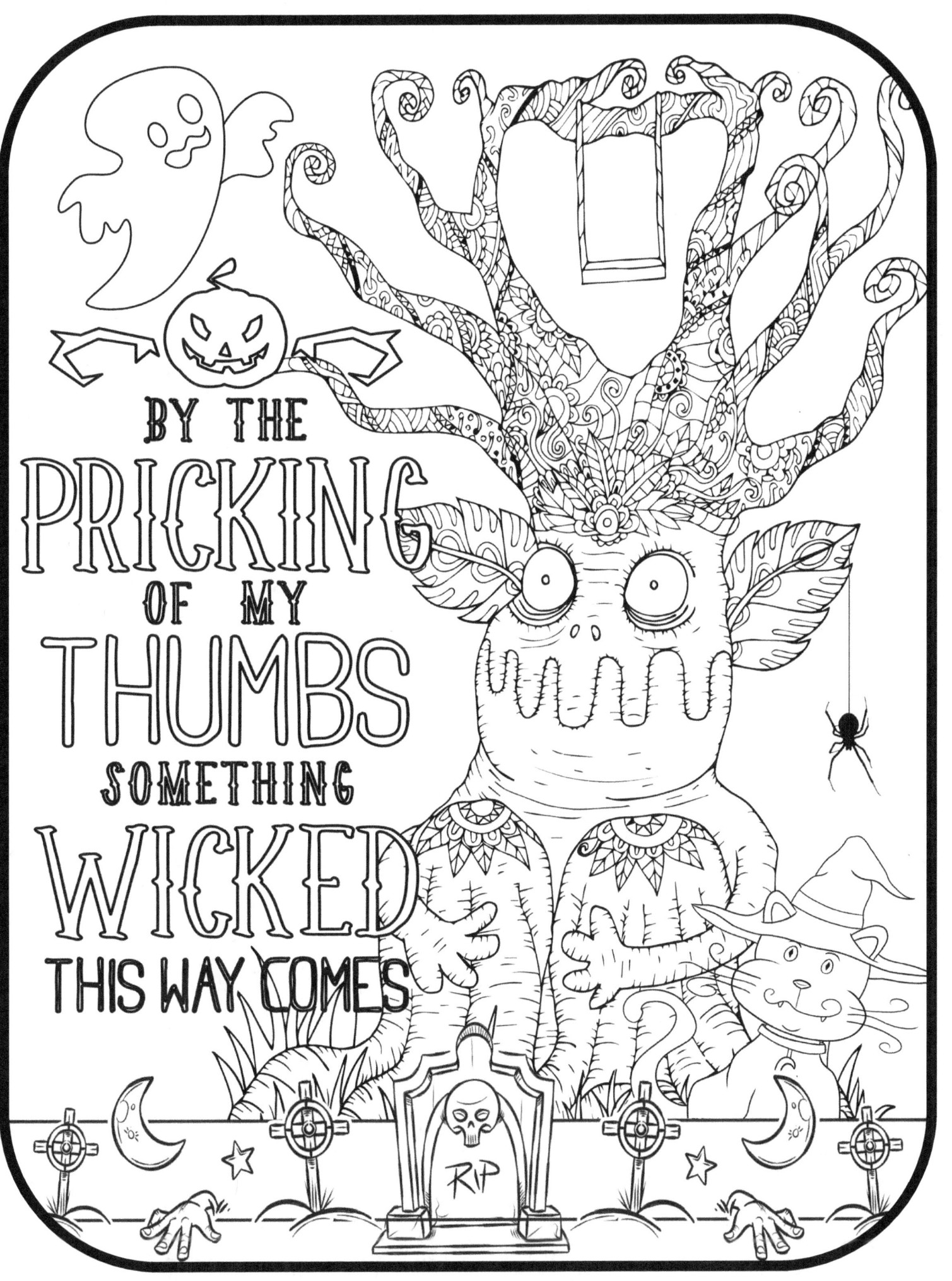

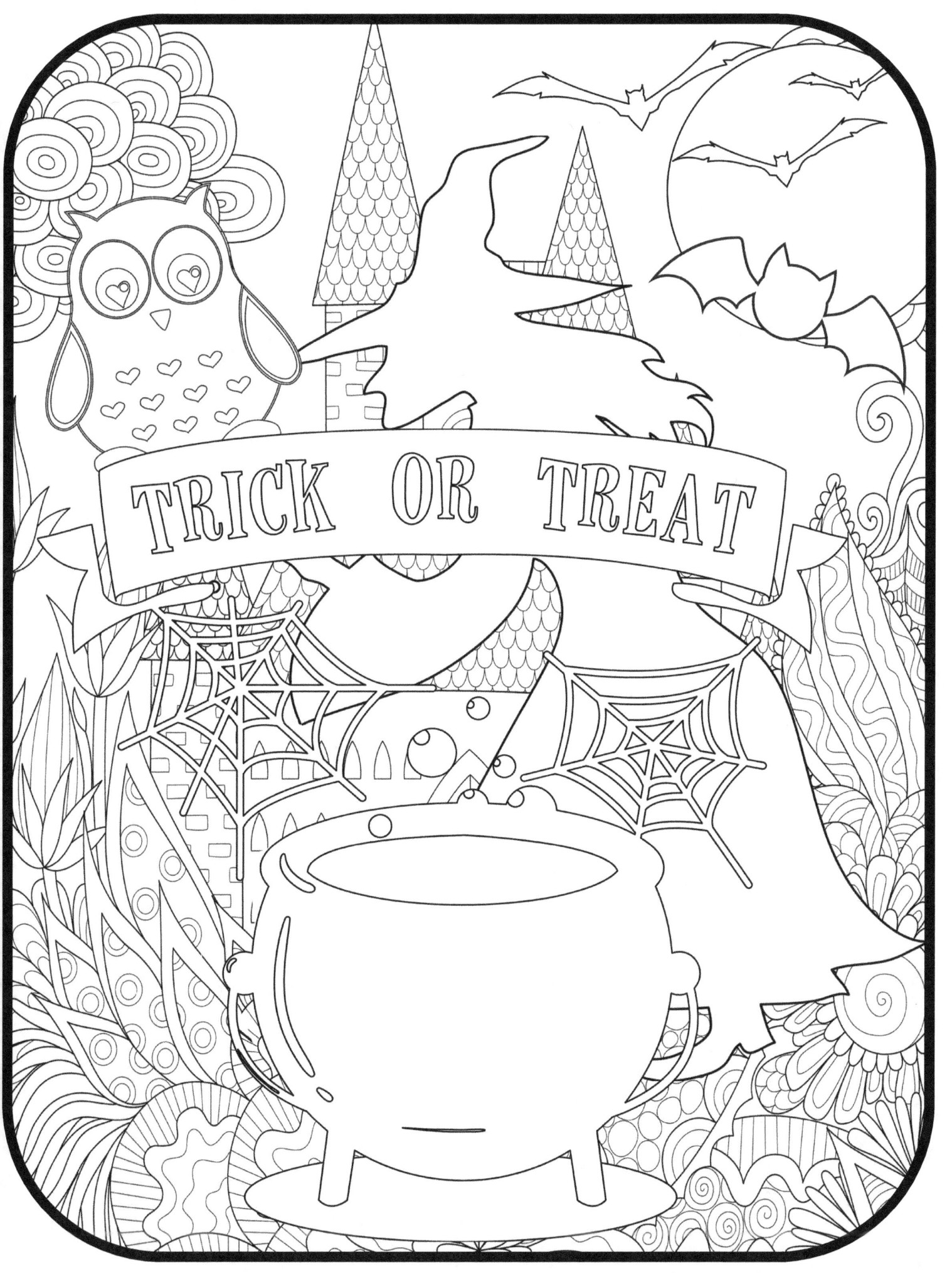

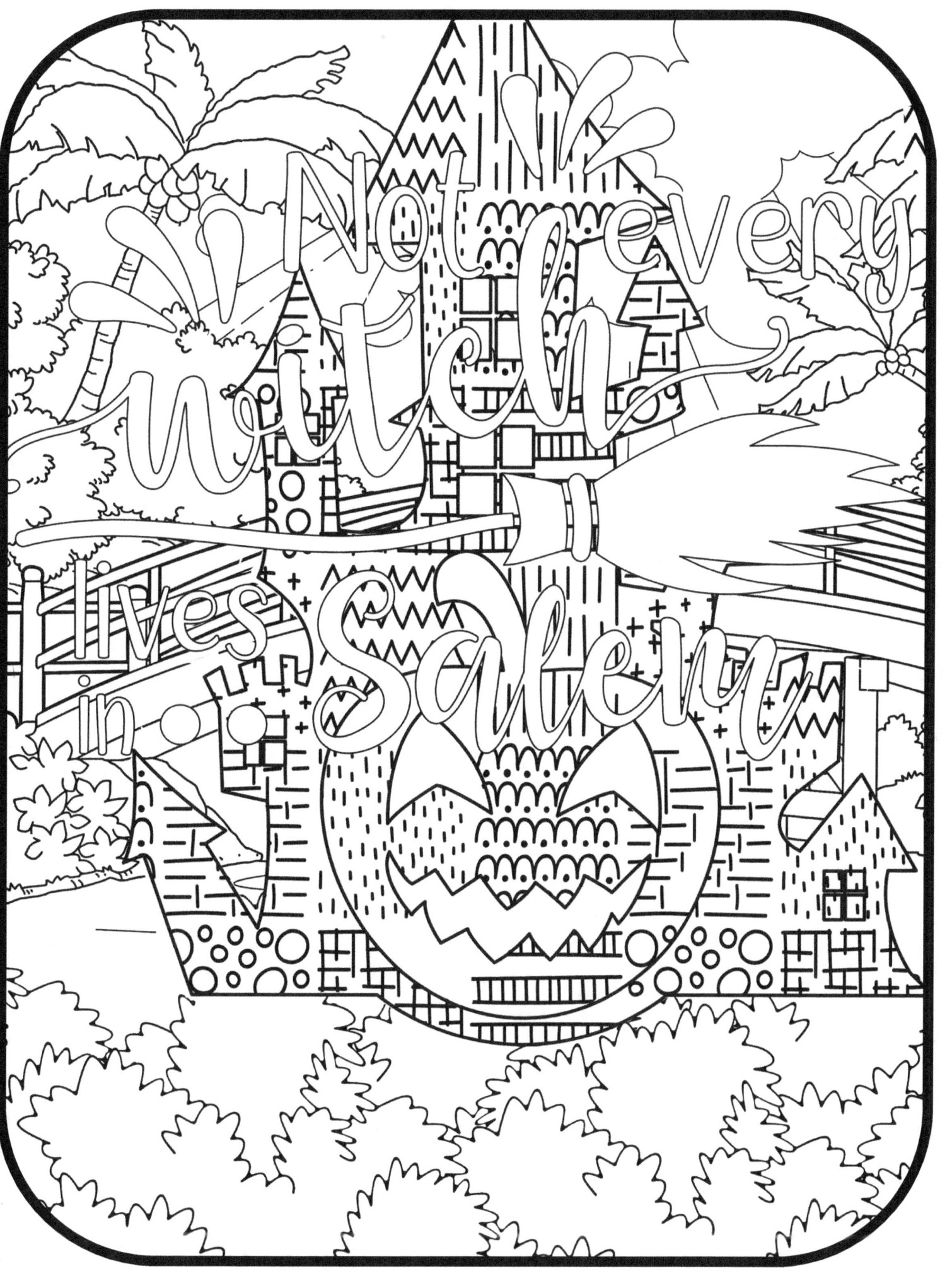

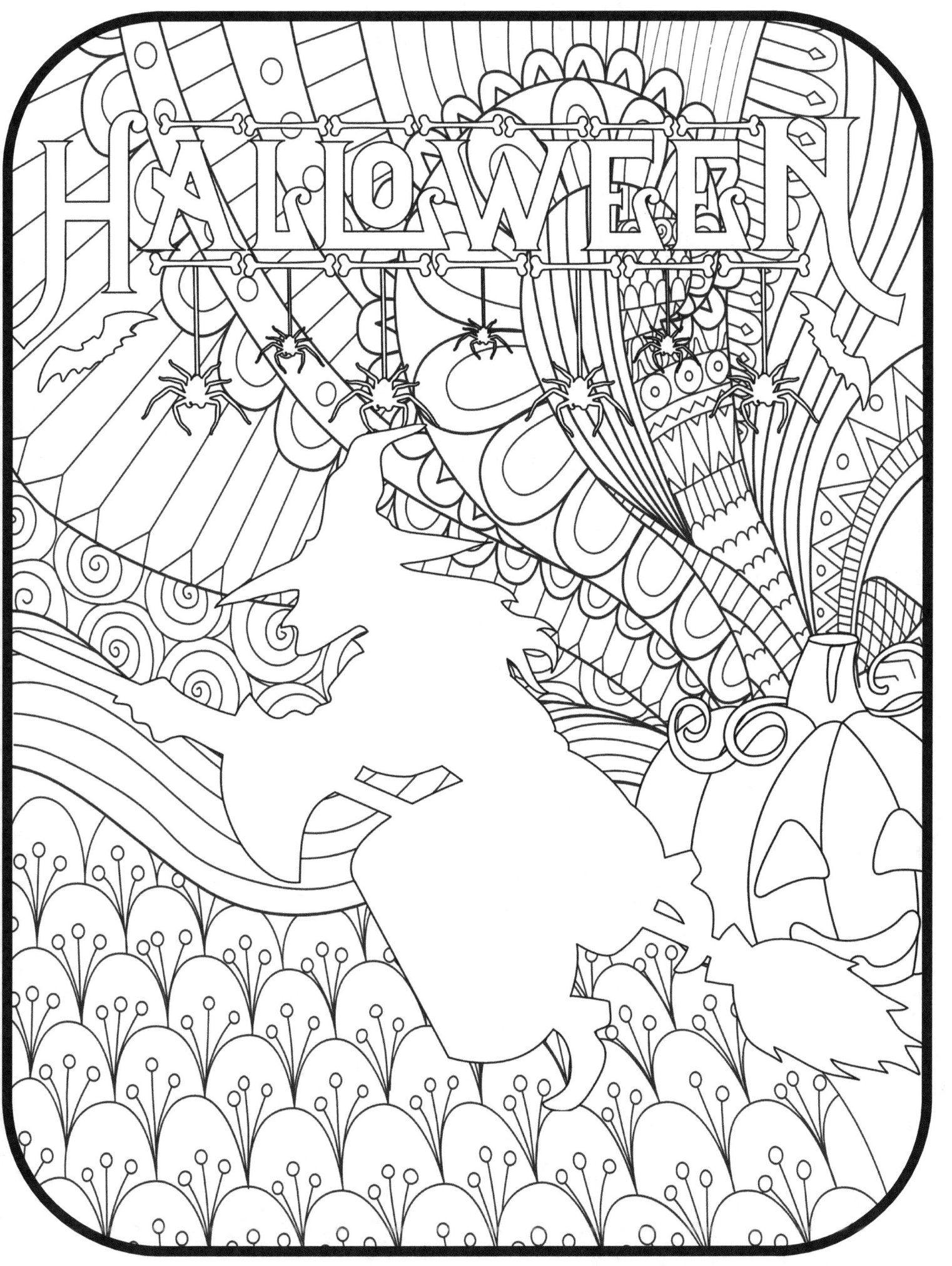

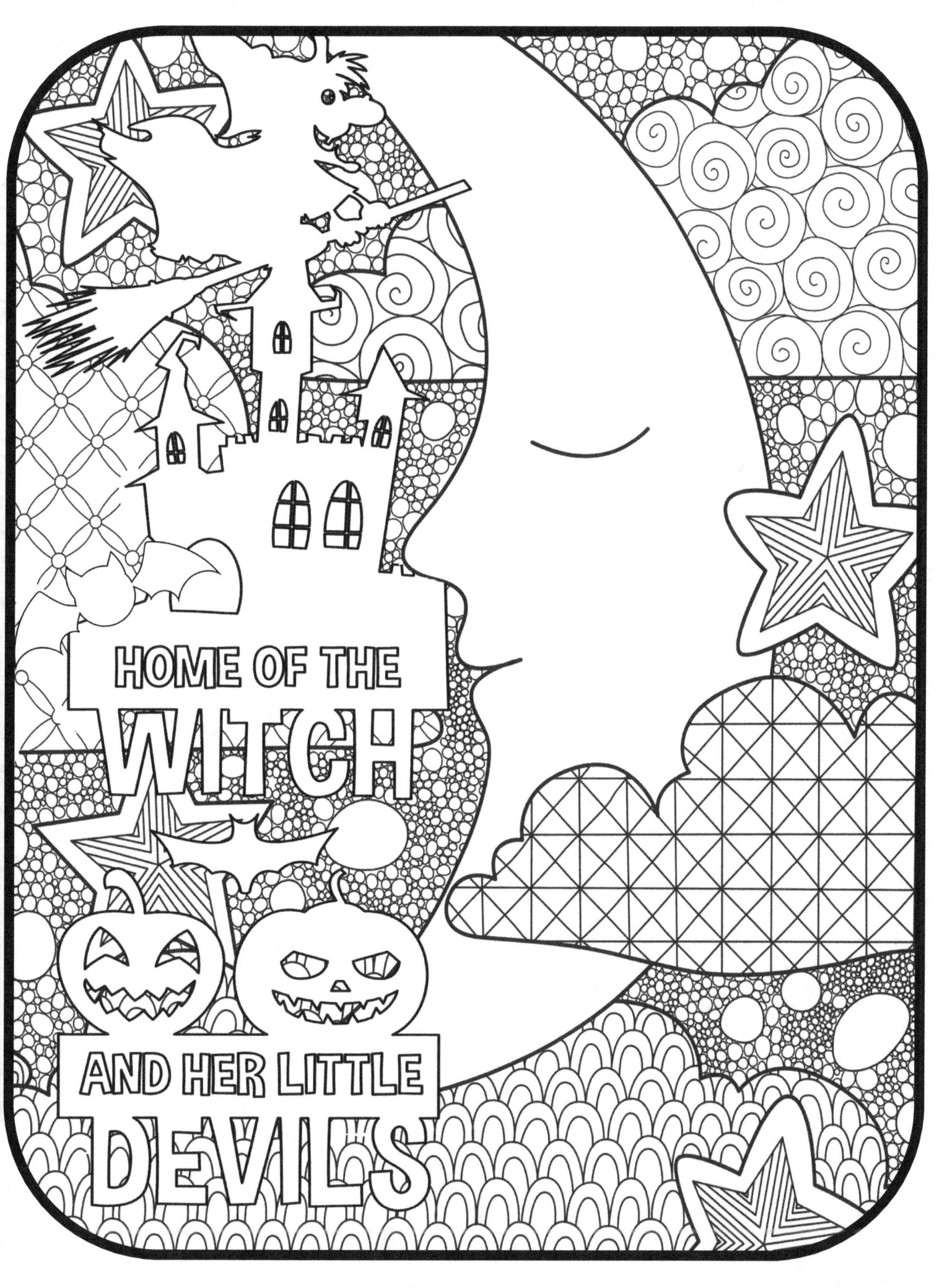

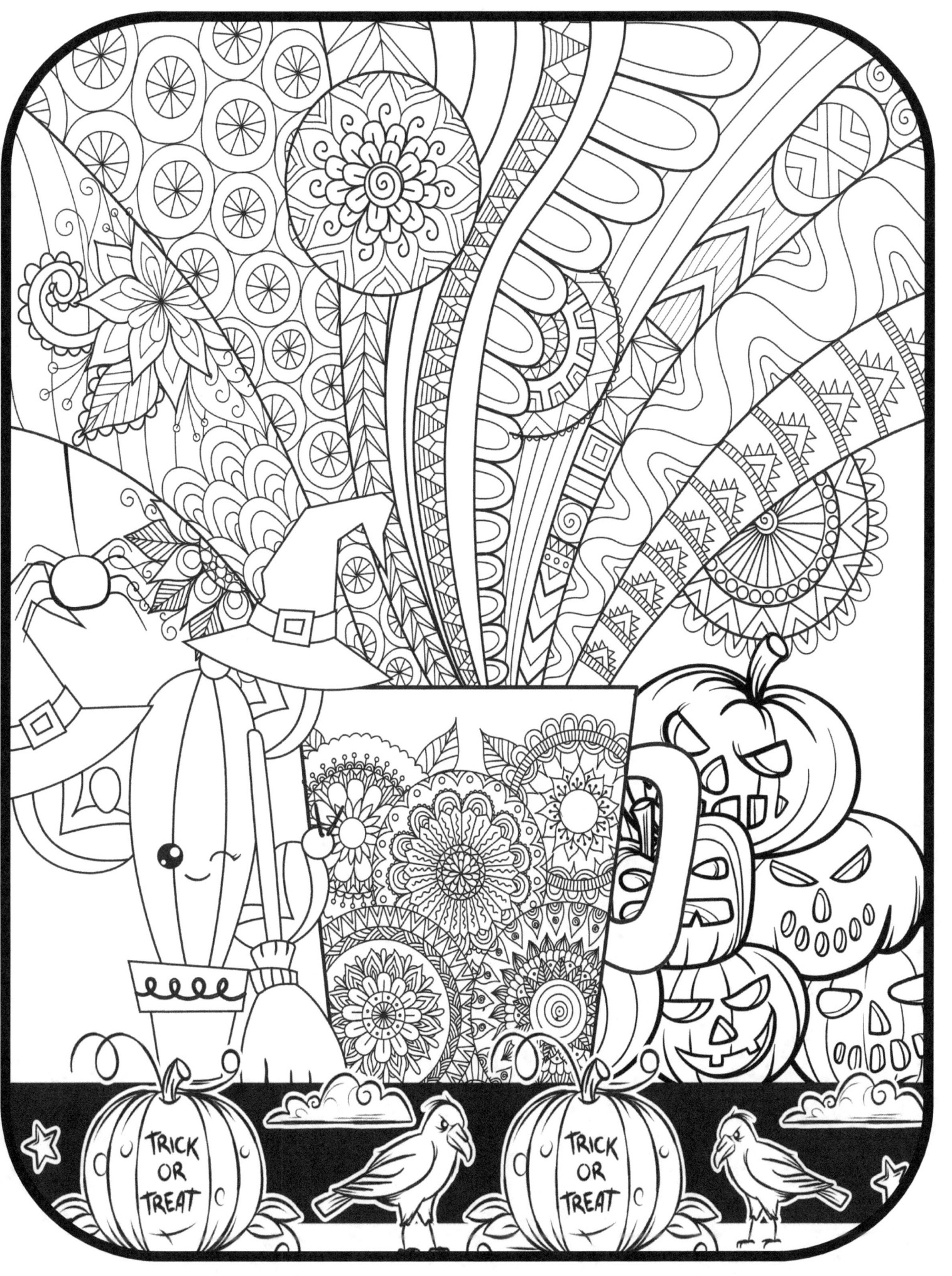

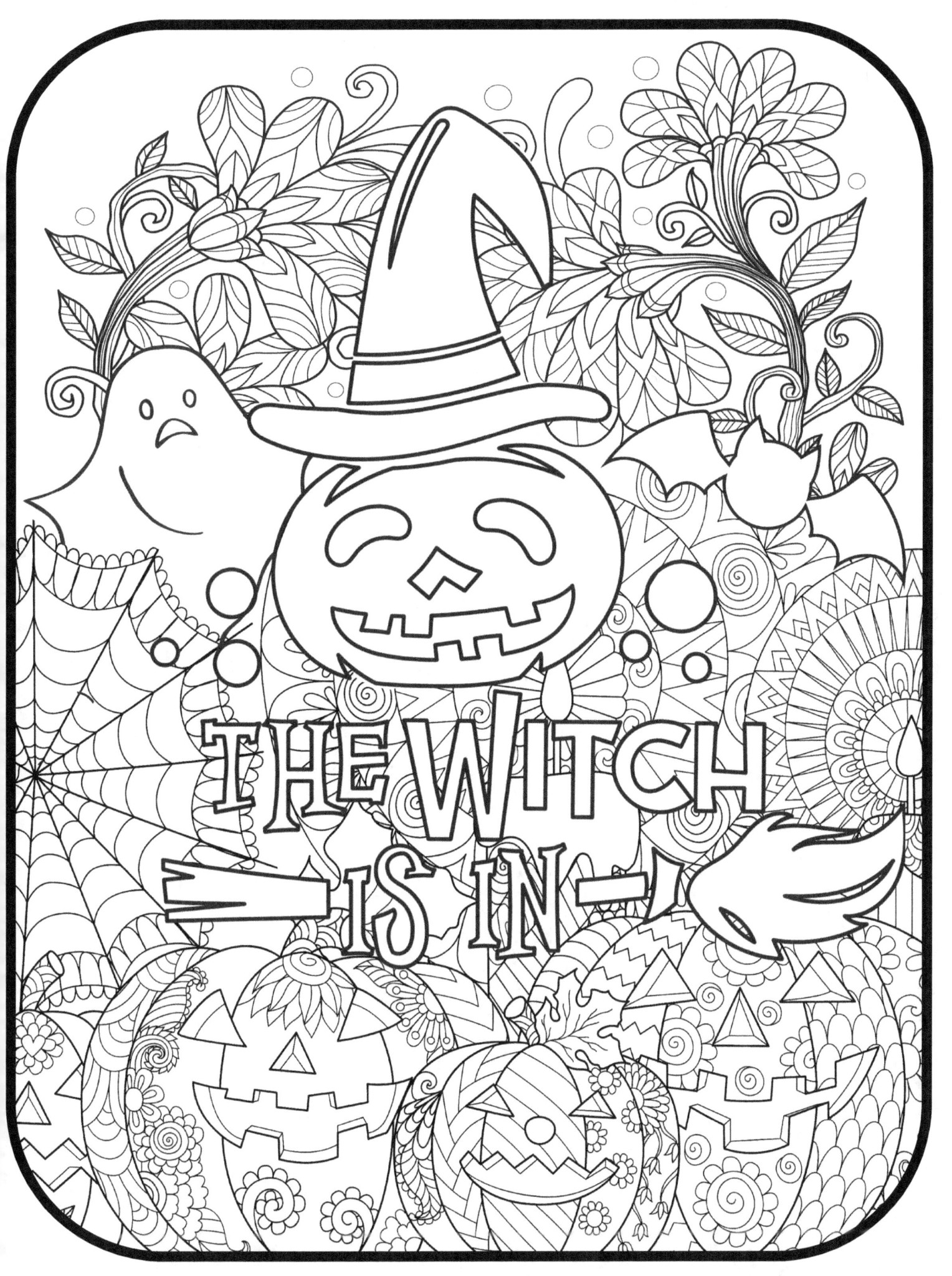

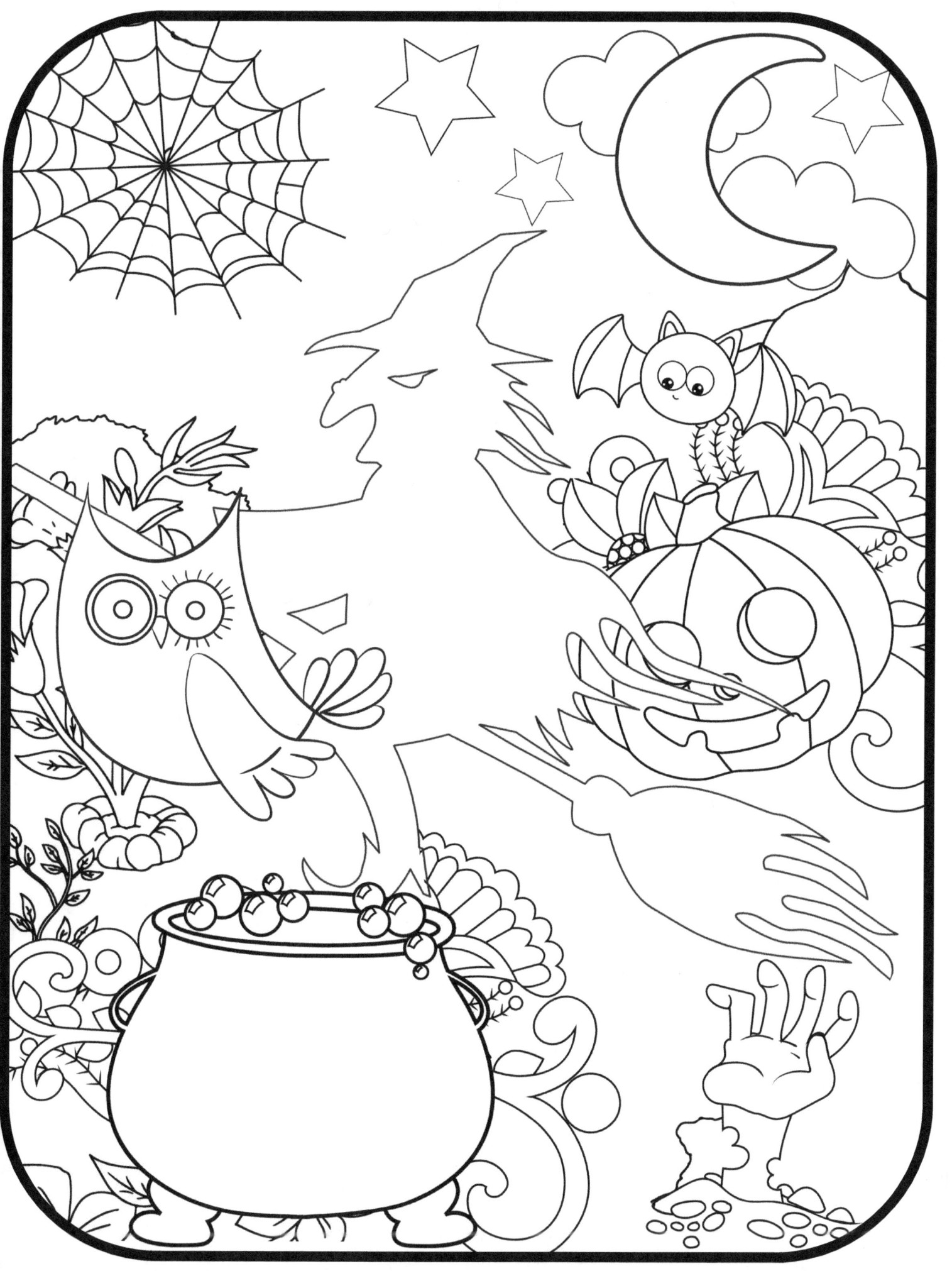

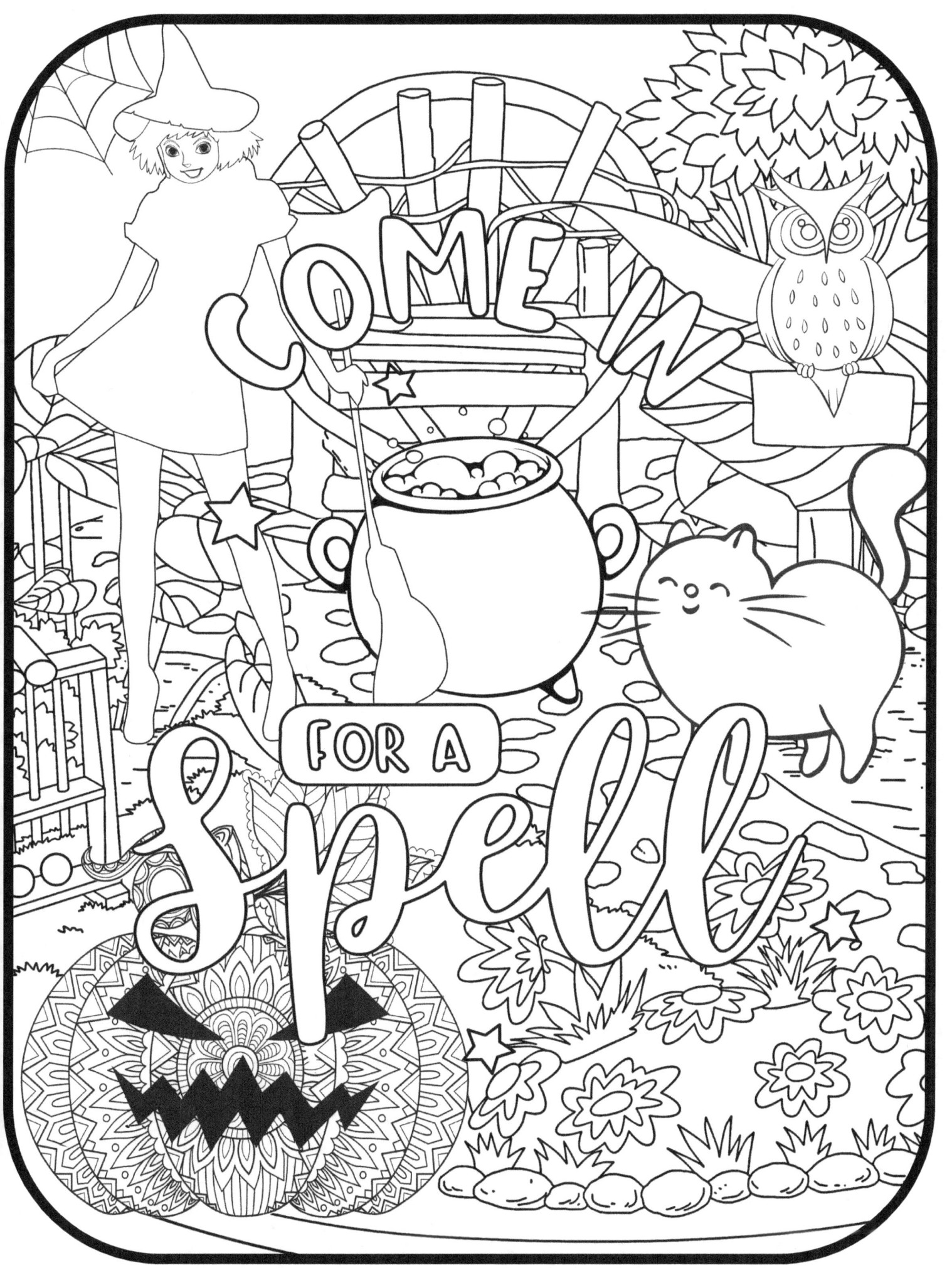

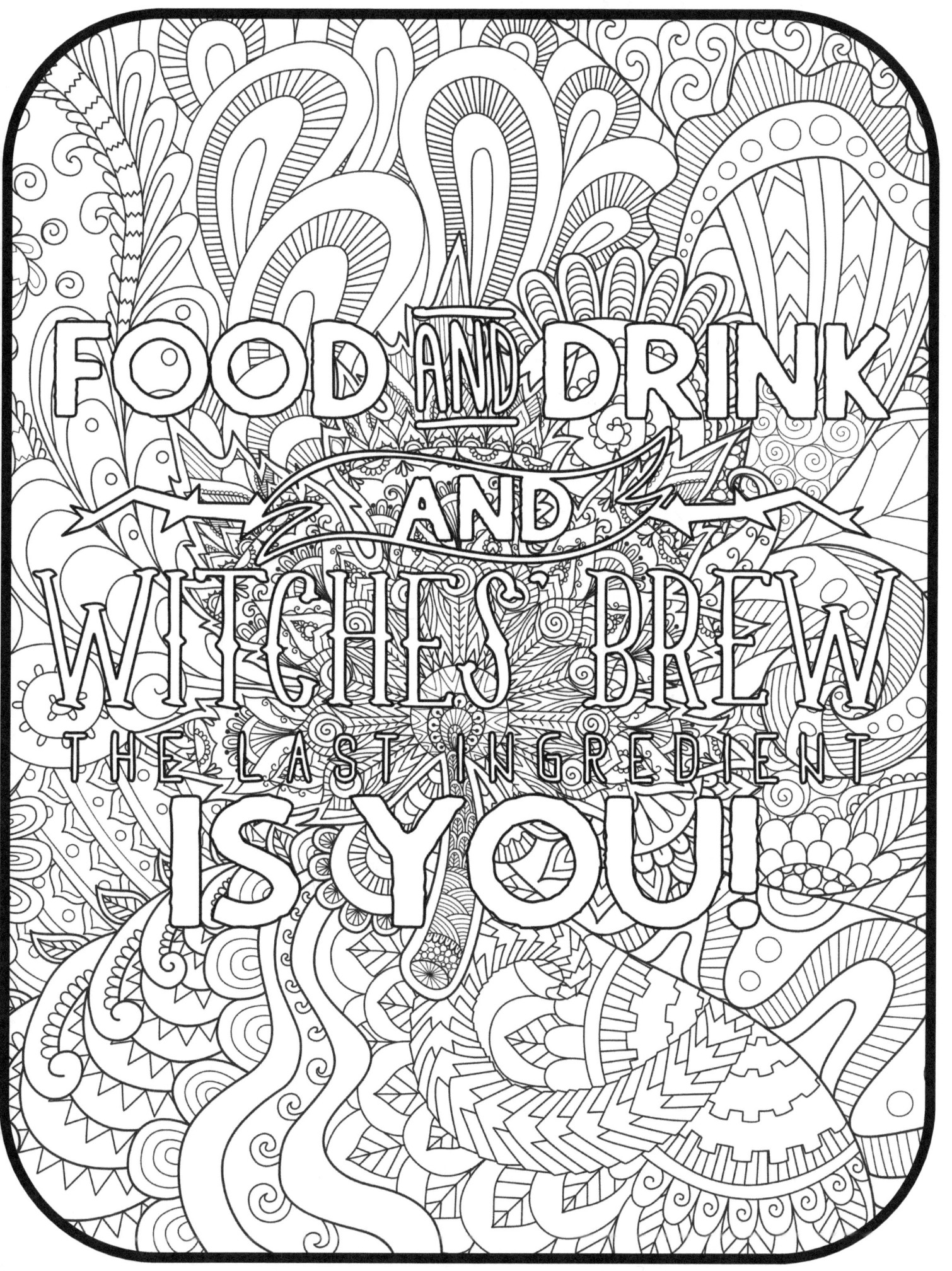

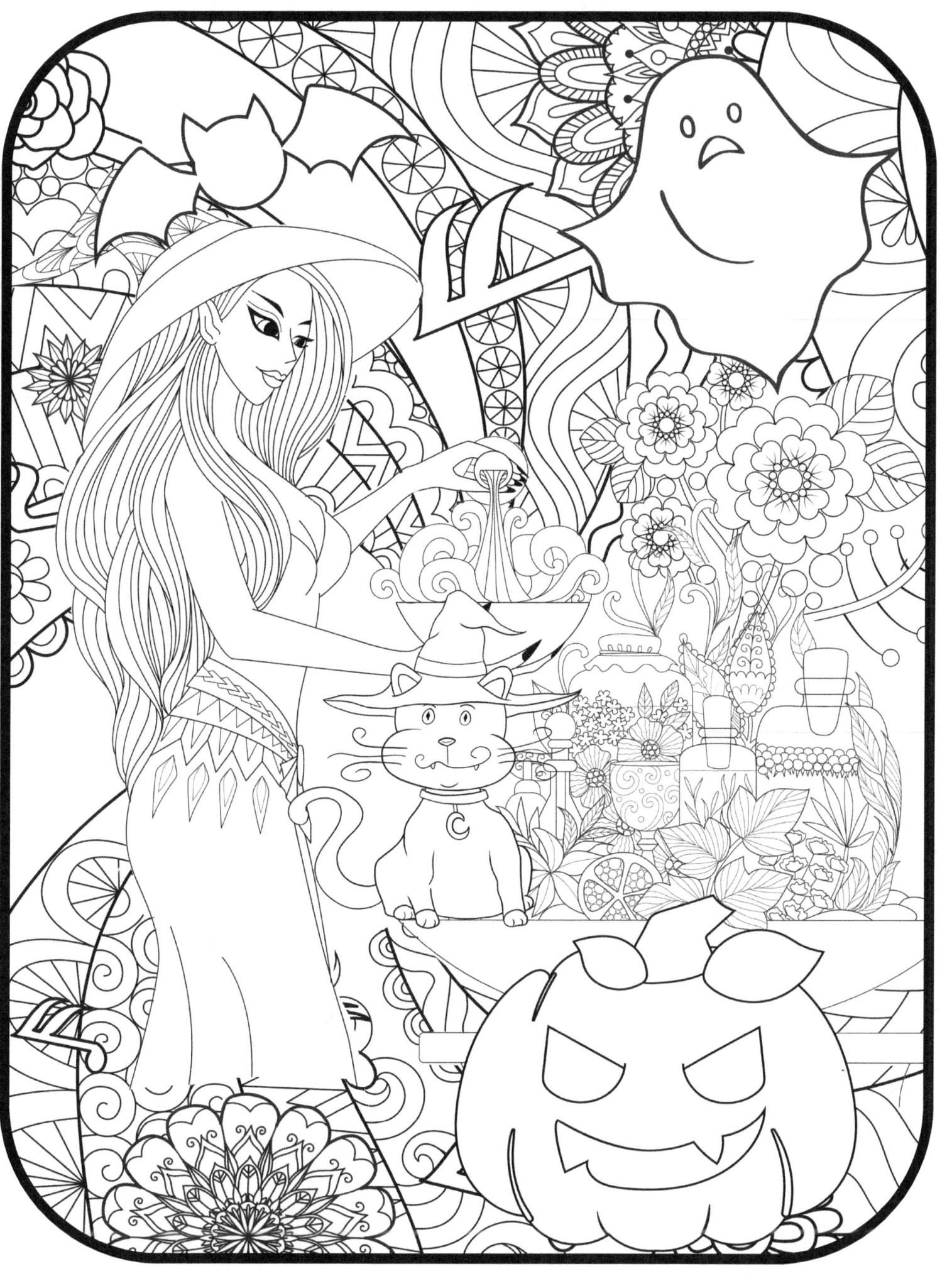

www.ingramcontent.com/pod-product-compliance
Lightning Source LLC
Chambersburg PA
CBHW082019230526
45466CB00022B/2723